CHOOSING AND MIXING COLOURS FOR PAINTING

An essential guide to colour and how to use
it successfully in your painting

JEREMY GALTON

Studio
Vista

Studio
Vista

Copyright © 1988 Quarto Publishing plc

First published in Great Britain in 1988 by
Studio Vista
An imprint of Cassell Publishers Limited
Artillery House, Artillery Row
London SW1P 1RT

British Library Cataloguing in Publication Data
Galton, Jeremy
Choosing and mixing colours for painting.
I. Paintings. Colour — Manuals
I. Title
752

ISBN 0289 80018 8

This book was designed and produced by
Quarto Publishing plc
The Old Brewery, 6 Blundell Street
London N7 9BH

Project Editor Hazel Harrison

Designer Hazel Edington
Photographer Rose Jones

Art Director Moira Clinch
Editorial Director Carolyn King

Typeset by Apt Image, Sussex
Manufactured in Hong Kong by Regent Publishing Services Ltd.
Printed by Leefung-Asco Printers Ltd, Hong Kong

Special thanks to Angela Gair, Kate Kirby

CHOOSING
AND MIXING
COLOURS
FOR PAINTING

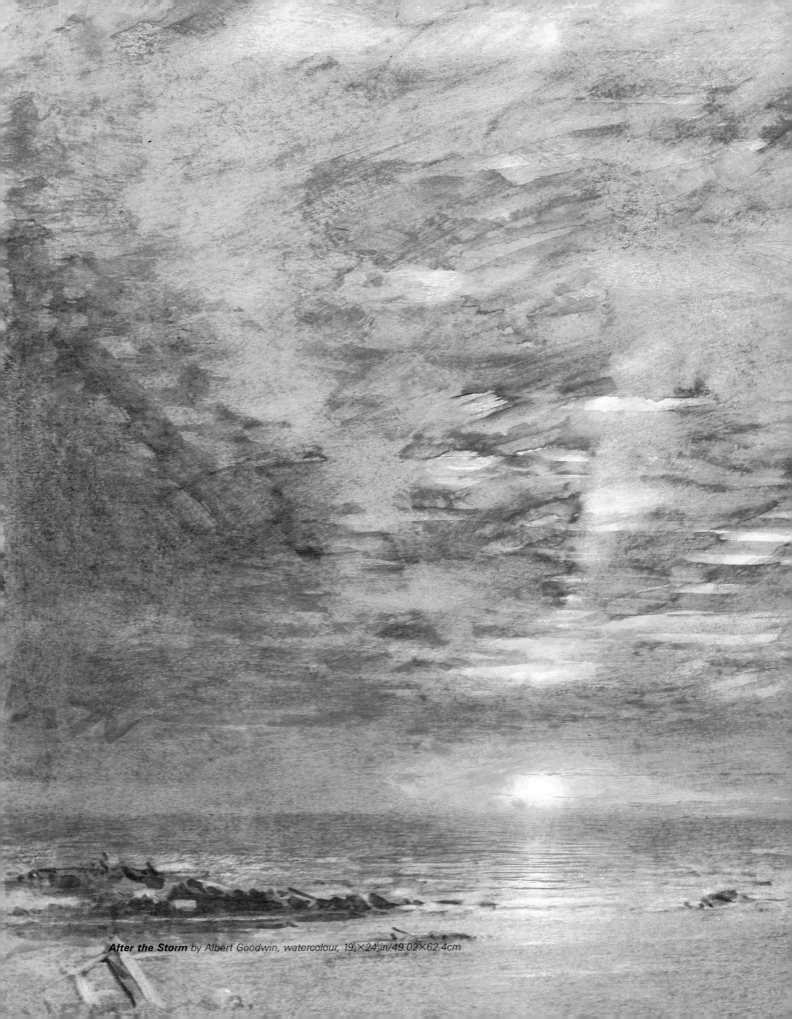

After the Storm by Albert Goodwin, watercolour, 19½×24½in/49.02×62.4cm

CONTENTS

1
ALL ABOUT PAINTS

Deciding to take up painting is easy enough, but the next step, that of choosing a particular painting medium, requires rather more thought. Some beginners choose oil, watercolour or pastel because an artist whose work they admire works with it, only to feel frustrated because it doesn't suit their style or the way they use colour. The process of mixing colour varies according to the type of paint used. Oil paints, acrylics and gouache colours, the opaque paints, are usually mixed with white as well as other colours; pastels have to be "mixed" on the painting surface itself, while watercolours can easily be spoiled and muddied by overmixing. In this chapter I help you to make a choice by explaining the characteristics, merits and limitations of each medium and telling you what equipment you'll need for each.

HOW PAINTS ARE MADE

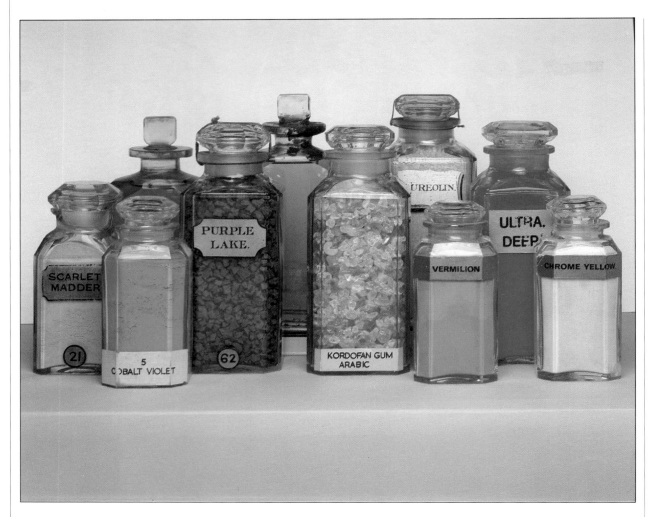

The main ingredient of all paints, including pastels, is a colouring substance — a pigment or dye. This is mixed with a colourless binding medium whose job is to hold the pigment in place on the painting surface. The binder varies according to the type of paint being made. Oil paints are mixed with a vegetable oil, usually linseed or poppy seed; watercolours with gum arabic; pastels with gum tragacanth or leaf gelatine, and acrylics either with the synthetic resin that gives them their name or with a similar one.

Until the 19th century, when rapid advances in chemistry began to be made, most pigments were obtained as naturally occurring mineral, animal or vegetable products.

Some, such as the "earth colours," which were and still are made from soil or rocks, were plentiful and inexpensive, but others, such as the brilliant blue (ultramarine) made from the rare mineral lapis lazuli, were very costly indeed. Ultramarine has been synthesized since the early 19th century, but vermilion, originally made from cinnabar, is still extremely expensive — a colour for special occasions only.

Many of the natural pigments lost their colour after a period of time, but nowadays substitute pigments are made in laboratories, and attain a high degree of permanence. Even so, some are more permanent than others, and the manufacturers of artists' paints (artists' colourmen) always give each paint a rating indi-

cating its degree of permanence. Those with the lowest rating are termed fugitive, meaning that the colours change or fade over the years on exposure to light and air, particularly polluted air.

Examples of such colours are the carmines and madders, which are considerably less permanent than the chemically synthesized alizarin. The fugitive nature of pigments is encountered in everyday life. Think of a jar of paprika or cayenne pepper exposed to the light. They soon lose their rich red colour and fade to light brown and colour photographs or posters end up with most of their colours lost except blue, because all the other colours are fugitive.

1 The pigment is dried in shallow trays before mixing.

2 The powdered pigment is then mixed with oil, a process which in the past was done manually.

3 The colour is then milled so that it is completely blended.

4 Finally the paint is removed from the rollers before being put into tubes.

OIL PAINTS

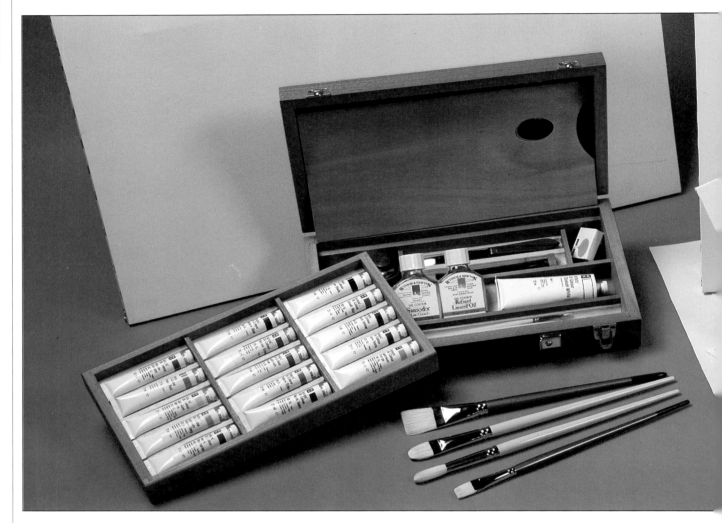

Oil paint consists of dry colour pigment powder ground in a natural drying oil such as linseed or poppy oil to form a thick, buttery paste. When a layer of wet paint is applied to the canvas the oil slowly oxidizes on contact with the air and forms a solid skin. This oxidizing process occurs with each successive layer of paint applied, and gives a special richness and depth to the colours. Linseed and/or good quality turpentine can be added to the paint to make it flow more easily. More oil will give your painting a glossy look, more turpentine a matt look.

The colour values of oil paints alter little during the drying process, though oil paintings do tend to yellow slightly over the years, the extent depending on which type of drying oil was used in the manufacture of the paints.

Working with oils

The appeal of oil paints undoubtedly has a lot to do with their tactile quality; their soft, viscous, buttery texture is irresistible to many painters. Oil paints also have a distinctive smell which, to me at least, is quite delicious. If you happen to detest the smell you can use special low-odour thinners available from some manufacturers.

Oil paints have been widely used by artists for centuries. With the possible exception of acrylics, oil paint is the most versatile of the painting media because there are so many different ways in which it can be handled. The paint dries slowly on the canvas, enabling the artist to manipulate it freely and extensively, and to produce an infinite variety of textures and effects.

It can be argued that the personality of the painter is expressed more readily in oils than in any other medium. Broadly speaking, there are two contrasting types of oil painting; first there is the considered approach, in which thin layers of colour are built up slowly over a prolonged period, often on top of a carefully planned underpainting. Then there is the direct *alla prima* approach, in which the painting is usually completed in a single session and without any underdrawing

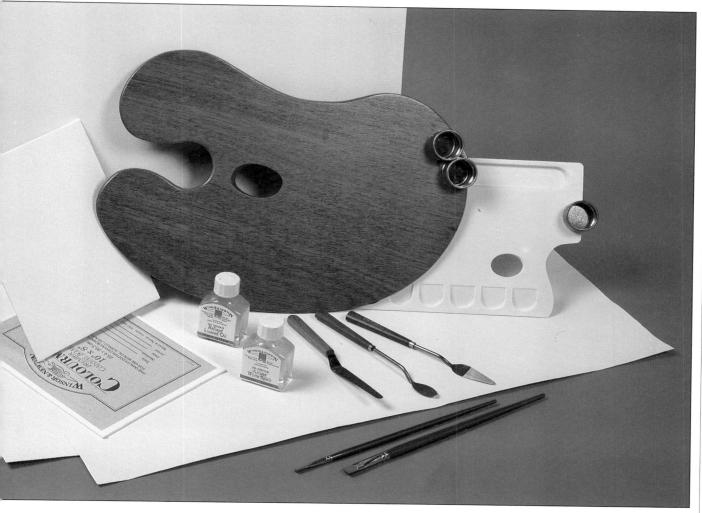

or underpainting. With this approach the paint is handled more freely and spontaneously, and various techniques may be employed within the same painting. For instance, you can apply thick paint with a brush or knife to build up a highly textured impasto; you can blend one colour into another; or you can apply opaque dryish paint very thinly, with irregular, scrubby brushstrokes — a technique known as scumbling. If you want to alter or correct a passage, the paint can be easily scraped or rubbed off, or if it is completely dry, simply painted over again.

Once dry, an oil painting can withstand quite rough treatment (within reason!), because the paint hardens to such a tough, flexible layer on the canvas. An old painting can also be cleaned without any damage to the paint itself.

Do oil paints have any disadvantages, then? Well, their slow drying time does present some problems, the most obvious one being that you are obliged to keep your still-wet canvas well clear of inquisitive children and hairy animals, and when painting outdoors, chances are that your painting will blow or fall over, inevitably landing "butter side down"!

Another point to bear in mind, and a most important one, is that if the paint is to be applied in layers, the first coat must be dry before the next is laid on, otherwise the paint surface is liable to crack in due course.

Oil paintings are traditionally done on canvas or canvas board, but a variety of inexpensive supports such as primed hardboard or even strong paper can also be used. Most artists use long-handled bristle brushes in a variety of shapes (the shape of the brush affects the type of mark it makes on the painting surface), but some use soft sable or synthetic-fibre brushes, while others prefer to lay the paint on with a special knife designed for the purpose, three of which are shown here. The type of palette chosen will depend very much on each individual's way of working. If you paint standing up, and like a large palette, the kidney-shaped one is the most comfortable to hold. It is a mistake to buy too much equipment to start with: the real basics are some brushes, the paints themselves, linseed oil for diluting the paint, and plenty of turpentine (or white spirit) for cleaning brushes.

11

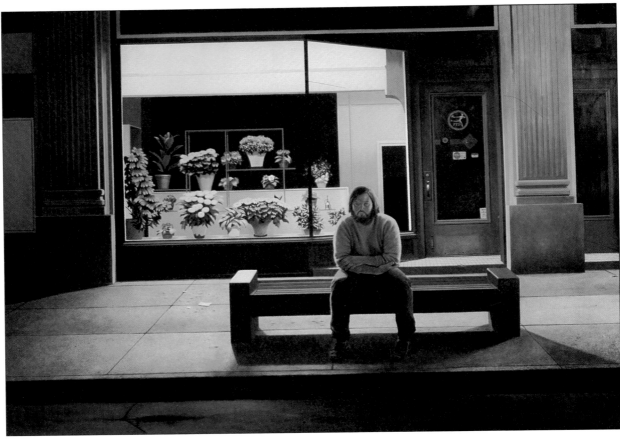

Bus Stop by Walter Garver, oil, 32×44in/ 81.3×111.8cm. This artist works on a large scale, and uses oil paint in an unusual way. He paints on hardboard primed with acrylic gesso, which gives an absolutely smooth, untextured surface, and he builds up areas of intense, flat colour by using the paint very thin, in a succession of semi-transparent glazes. He is particularly interested in the way light dramatizes ordinary subjects, and this scene, lit by artificial light, has something of the quality of a stage set, with very strong contrasts of light and dark.

For the same reason, you should always adopt the principle of "fat over lean" when painting in oils. This means that oil paint diluted with a high proportion of oil ("fat") should always be applied *over* paint diluted with thinners ("lean"). If lean paint is applied over fat, the lean layer will dry first. The fat layer underneath dries more slowly, and as it does so it contracts, causing the dry paint on top to crack.

Beginners are often put off the idea of painting in oils because of all the equipment needed and the fact that they are so messy. These are disadvantages, especially if you want to paint out of doors. The minimum equipment you need is a box of oil paints (which come in tubes), bottles of linseed oil and turpentine to thin the paint, a palette on which to mix and thin the paints, some brushes and a primed surface to paint on. You will also need white spirit to clean your brushes, a rag to clean the palette and an easel to hold your picture. (I often simply use my lap if I'm painting a small picture out of doors.) Make sure you can

Red Tablecloth by Robert Buhler, oil, 20×24in/50.8×61cm. Oil paint can be used in many different ways, but it invites itself to the kind of thick, rich application seen here, where each brushstroke of the barely thinned paint is discernible. Such brushmarks form an integral part of an oil painting, and give a characteristic texture to the picture surface, unique to this medium. Notice how the artist has left the contours and edges loosely defined, with the pale ground showing through in places, enhancing the impression of gentle intimacy.

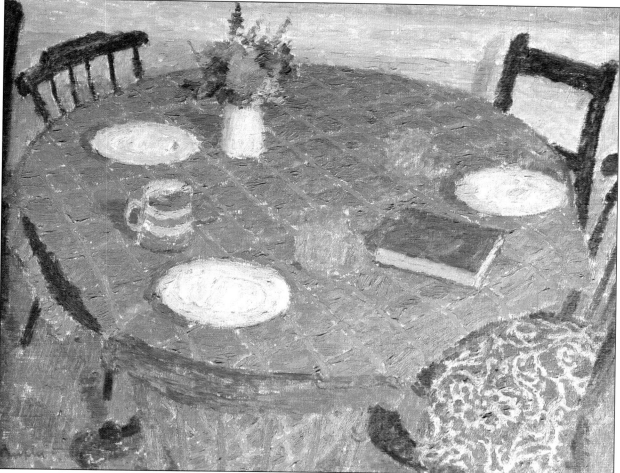

take the wet painting home without smudging it! You should wear old clothes or an apron or smock because, however careful you are, the paint always seems to find its way everywhere it shouldn't. I find that paint-laden brushes somehow flick out of my hand and into my lap or onto the floor — so be prepared! Accidental spillages on clothing can be removed with a rag and white spirit. A universal solvent such as Swarfega, followed by a rinse in water, is best for cleaning the hands. If I'm out painting a landscape for a whole day and want to get the paint off my hands to eat a picnic lunch I take along one of those tins of acetone-based cleansing pads which are designed for freshening up the face. I mention this because it is important not to let paint contaminate your food as many of the pigments are extremely poisonous (containing lead, cadmium, and mercury among others).

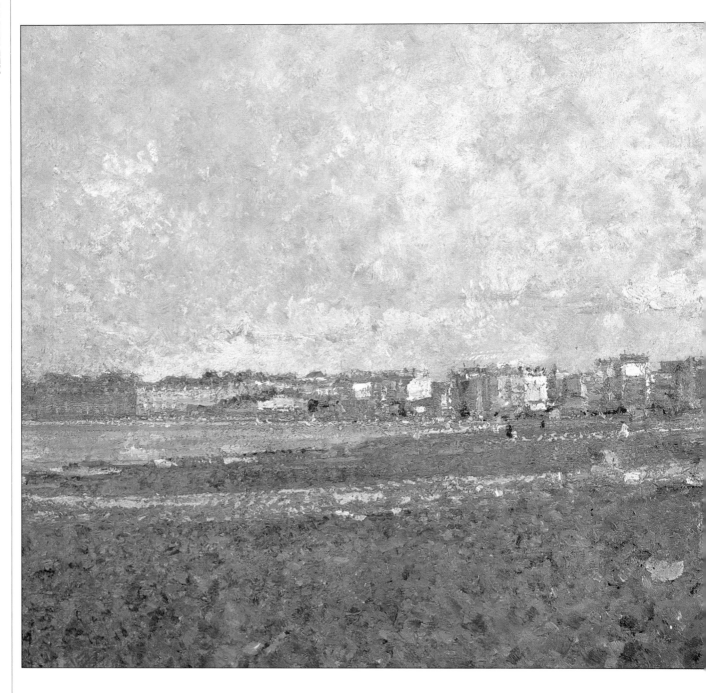

Evening Shadows, Weymouth by Arthur Maderson, oil, 25×38in/ 63.5×96.5cm. When oil paint is applied in rich impasto, as here, it never loses the glistening-wet look it had the day it was painted. Here, layer upon layer of thick paint has been applied loosely, with each small patch of colour remaining separate from its neighbour. The artist has taken an obvious delight in the textural qualities of the paint, but has at the same time created a realistic impression of a particular scene. Making the paint play this kind of dual role is one of the secrets of a really good painting.

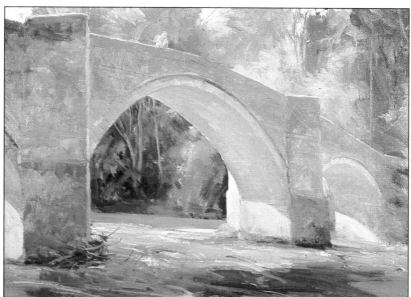

Bardes Bridge, Wasdale by David Curtis, oil, 16×20in/40.6×50.8cm. Here the oil paint has been applied so thinly that it looks at first glance almost like watercolour, with the white ground illuminating the paint from behind. On closer inspection, however, thicker, drier paint can be seen in places, notably in the areas of the left-hand buttress and the water. The individual brushstrokes have hardened in exactly the shape in which they were laid — one of the characteristics of oil paint.

WATERCOLOUR AND GOUACHE

Watercolour paper is sold in a variety of different weights, both as single sheets or in pads, which are a good choice to start with as no drawing board is needed. Single sheets of lightweight paper should be stretched before use or the paper will buckle when the wet paint is applied. Otherwise, all you really need is the paints themselves, either in tubes, pans or half pans, a paintbox or set of palettes for mixing and three or four brushes in different sizes. The best ones for large washes are the square-ended ones; the small, pointed ones are most useful for detailed work at the end of a painting. The same brushes can also be used for gouache, but some artists like to apply the paint more thickly, using bristle brushes, or they use a combination of both. There is really no hard and fast rule about paper types for gouache. If used wet, watercolour paper is the best choice, but the coloured Canson Mi-Teintes paper shown here is excellent for a drier application.

Watercolour paints consist of very finely ground pigment mixed with gum arabic until it is fully emulsified. This water-soluble gum acts as a light varnish, giving the colours their characteristic sheen. The paints are supplied either in tubes or in small blocks called pans or half pans. These have some glycerin added to keep them from hardening and are known as semi-moist. Watercolours can also be bought in dry cakes, which theoretically contain pigment in its most pure form, with no added glycerin, but they are not much used nowadays as it takes a long time to release the colour from them.

Obviously, watercolour paintings are more fragile than oils and other opaque media, and must be mounted and framed under glass immediately or stored very carefully. The colours tend to fade slowly when exposed to bright sunlight so it is wise to keep them away from a sunlit window.

The equipment you need for watercolour is much simpler than for oil — the paints themselves which can be packed in very small boxes, a palette, which may simply be the lid of the box, a few brushes, a jar of water and some paper. It is therefore much more portable and many painters prefer using watercolour when working away from home.

Working with watercolour

Watercolour has a unique delicacy

On the Bay of Sorrento by Hercule Brabazon Brabazon, watercolour, 8¾× 11¾in/22.2×29.8cm. Very loose handling of paint gives this picture the characteristic free, immediate effect unique to watercolour. Small touches of opaque white have been used in the foreground, but much of the picture has been painted wet-in-wet, a technique which produces unpredictable and not always entirely controllable results. The watercolourist is always on the lookout for ways of using semi-accidental effects to enhance the mood of a painting.

*The **Yellow Room** by Lucy Willis, watercolour, 22×31in/55.9×78.7cm. The transparent nature of watercolour is apparent here, with the white paper glowing through all but the blackest areas. On both the figures and the right-hand wall, washes have been laid one over another, and in the extreme foreground some of the pigment has separated, giving a granulated effect, an example of the unpredictability of watercolour washes laid over earlier paint layers.*

and transparency that make it the perfect medium for capturing the subtle nuances of light and colour in nature. When you paint in watercolour you are in effect painting with pure water into which a small amount of colour has been dissolved. The white, reflective surface of the paper shines up through these transparent skins of paint, and this is what gives the colours their inner light. A good watercolour painting has a freshness and poetry that are unmatched in any other medium. However, it is a popular misconception that bright or dark colours cannot be obtained in watercolour.

The disciplines of watercolour painting are quite distinct from those of oils. Because water dries relatively quickly, especially when working out of doors, you must work equally quickly; you can't manipulate the paint or push it around as freely as you can in oils. You must therefore have the courage of your convictions and be prepared to work boldly and confidently, with no hesitant pickings or proddings. In addition, a certain amount of planning and forethought are required because mistakes cannot easily be rectified.

Unlike opaque media, in which light colours can be applied over dark ones, transparent watercolour requires the artist to begin with the lightest tones and overlay with further washes.

The fluid nature of watercolour makes it less predictable than any other painting medium, but this is more than compensated for by the range of exciting and beautiful effects it can create — sometimes more by accident than design. Washes are the foundation of watercolour painting. When a brush fully charged with paint is swept across damp paper, the strokes dissolve together and the colour shines out from the paper. Watercolour washes can either be precisely controlled, or allowed to flow together wet-in-wet so as to form exciting interactions.

Watercolour can also be used successfully in combination with gouache, or body colour, a technique

St Mark's, Misty Morning, Venice *by
Ken Howard, watercolour, 7×9in/
17.8×22.9cm. This painting, although
containing a wealth of architectural
detail, is quite loose in handling, showing
how watercolour can be used freely and
accurately at the same time. Each layer
of paint has been laid over previously dry
washes so that there is very little mixing
on the paper. Some highlights have been
added in opaque white.*

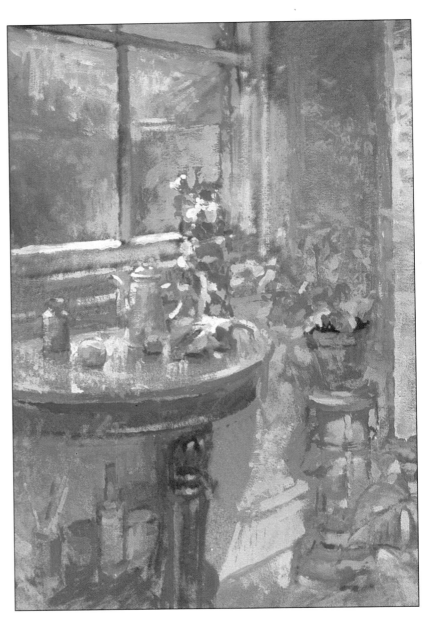

Evening Interior by John Martin, gouache, 18×12in/45.7×30.5cm. Here gouache has been applied so dry that it almost gives the appearance of pastel. This artist has chosen to work on a mid-grey paper, which has been left bare in places to form an integral part of the painting. Gouache, unlike true watercolour, is totally opaque, each brushstroke obliterating the one below, but care must be taken to apply each subsequent layer lightly or the wet paint will disturb that beneath it, muddying the colours and losing their brilliance.

fully exploited by J. M. W. Turner, and many modern artists also use it with pastels, coloured pencils or pen and ink.

Gouache

Gouache is essentially an opaque version of watercolour, made by mixing the same pigment with some zinc white. It is sold in tubes, pots or bottles, often labelled "designers' gouache colours." Some of the colours have the same names as their counterparts in watercolour and oil, but in addition there are a host of others with names like grenadine, Phoenician rose, ocean blue, onyx green and Parma violet. Each manufacturer seems to have its own range of colours.

Since the paints are opaque, they are usually handled more like oils or acrylics than like watercolours, although they can be thinned and used semi-transparent, just as oils can. In some ways, gouache is a tricky medium to use successfully. Although mistakes can be over-painted, and light colours laid over dark in a way that is not possible

Olive Trees near Ronda by Jeremy Galton, gouache, 7×10in/17.8×25.4cm. Most of the colours in this painting have been mixed with quite a lot of white, producing a high-key picture compatible with the dazzling light of southern Spain. The distant mountains have been lightly glazed over with white paint used sufficiently thin for the colours beneath to show through, a technique commoner in acrylic than in gouache.

with watercolour, the paints remain water soluble even when dry, which means that putting a layer of wet paint over another layer below tends to stir up and muddy the paint already there. The other disadvantage is that the colours dry considerably lighter than they appear when wet, so it can be difficult to judge what the finished effect will be. Gou-

ache paints are quite matt when dry, and have none of the luminosity of watercolours — because of their opacity, light cannot be reflected back from a light ground below. However, they have many advantages for a beginner. They dry very quickly, which makes them useful for rapid landscape painting on the spot — the first landscapes I ever

painted were in gouache, one of which is shown here. They are also excellent for laying solid areas of consistent colour, which cannot be done with either oils or watercolour; for this reason they are used extensively in design and illustration work. Finally, they are less messy than oils, and the equipment needed is more compact.

ACRYLICS

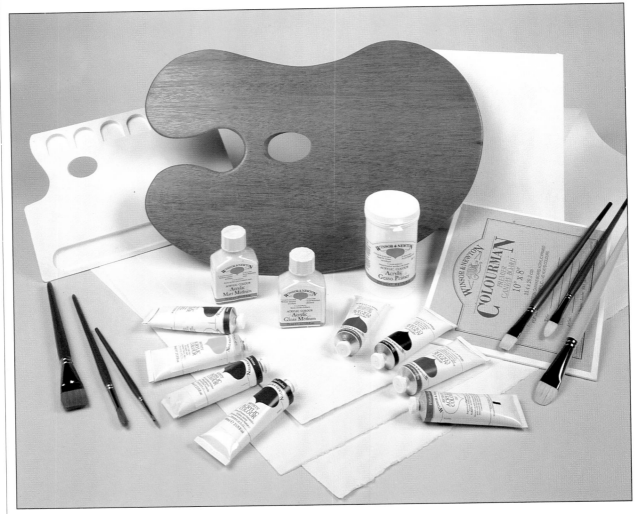

The development of acrylic paints went hand in hand with the development of plastics, indeed the acrylic medium is a plastic, made from petroleum products. The paints were only introduced in the '50s in America and the '60s in Britain, so their full potential is still being explored by artists. Acrylics are the most permanent of all paints; because the medium is resistant to oxidation and chemical decomposition, they do not yellow with age as oils do, nor do they fade as do watercolours. The are also the fastest drying of all paints, and once the paint has set it cannot be redissolved.

Acrylics will adhere to almost any surface, so can be used on canvas, boards or paper. Priming is not strictly necessary, but if it is used it must be an acrylic primer sold specially for the purpose, not an oil-based one (oil paint can be used over acrylic, but not vice versa). The equipment needed depends on the way the paint is to be used. If it is being laid on relatively thickly, like oils, then it is mixed on the same type of palette and applied with the same brushes, but it can also be used thinly for small-scale, detailed work, in which case watercolour brushes and palette are a better choice. Whatever brushes are used, they must be cleaned repeatedly throughout the course of a painting, as soon as the paint looks like drying, as otherwise it will be the end of that

Because acrylic is such a new type of paint, and there are so many different ways of using it, it is not possible to lay down the law about what to paint on and what to paint with. It can be used thickly, like oils, in which case the same equipment can be used (canvas, boards and bristle brushes), or it can be used very thinly and applied with soft sable or synthetic brushes. However, one rule to remember is that acrylic should never be used on a surface with an oil-based ground, so if you intend to prepare your own canvases or boards, always use the special primer shown here (this can also be used on paper). Beginners are advised to start with an inexpensive plastic palette (or even an old plate) as the paint hardens very quickly and cannot be removed when dry.

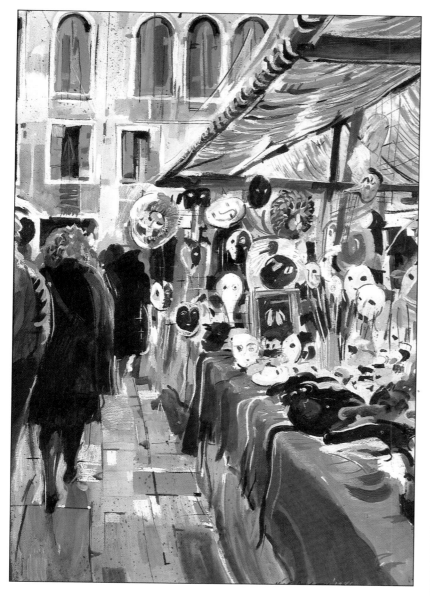

Venetian Market by Nick Andrew, acrylic, 30×22½in/76.2×57cm. Here the paint has been used quite thin, with some layers allowed to overlap others. The white ground showing through these transparent washes, or glazes, produces colour mixes quite different in appearance to those made by premixing the paint on the palette. Final touches have been added in pastel. Acrylic dries so rapidly that each layer can be applied without danger of muddying or diluting the layer below; many oil painters use it to block in underpaintings as they can work over it almost immediately.

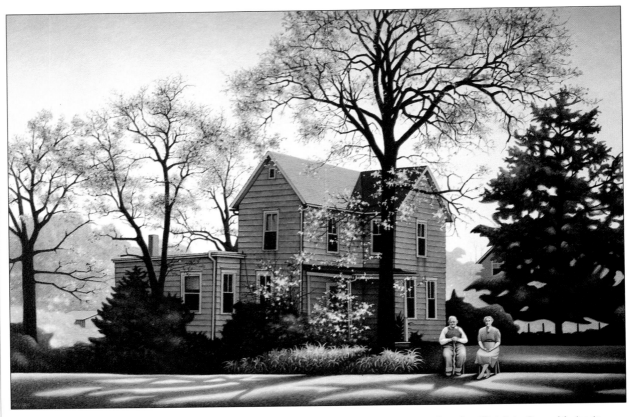

Evening Watch by Roger Medearis, acrylic, 16×24in/40.6×61cm. As a student, Medearis learned to paint with egg tempera, and he uses acrylic in a similar way, applying thin scumbles alternating with glazes, and building up coat after coat of paint. Of all the painting media, acrylic is the one best suited to this approach as the paint dries so rapidly. The same technique used in the slower-drying oil paint can not only take a very long time but also has a tendency to become overworked. Medearis works on either hardboard or canvas primed with acrylic gesso, and because his emphasis is on tonal values he favours a very limited palette — for some years he used only the primaries, plus black and white.

brush. The paints are sold in tubes or pots, and great care must be taken to replace lids and tube tops or the paint will dry out and be useless.

Characteristics of acrylics

Because acrylics are such a new medium, they are an invitation to experiment — no one can really lay down the law about how they should be used. They can be applied just like oils (although they do not look the same, being more matt in finish), and many artists use them to build up thick impastos. They are suited to this technique because they are so fast drying, but they are equally well suited to the technique of glazing. Innumerable layers can be laid one over the other, giving wonderful luminous effects. The two techniques can also be combined, with thin glazes laid over thick impastos — indeed the possibilities are almost endless.

The paints can be thinned either with water or with a special acrylic medium specially formulated for the glazing technique. This can be bought in both a glossy and a matt

Black Hills by Hugh Byrne, acrylic and watercolour, 26×14½in/66×36.8cm. The beauty of acrylic is that it can be used in so many different ways. This artist combines it with watercolour, thinning it with both water and acrylic retarder and laying a series of transparent washes on stretched watercolour paper. He finds that the acrylic, even thinned, provides extremely brilliant colours, which can then be modified as necessary by washes of pure colour laid over them.

finish. For those interested in impasto work, a special impasto medium can be obtained to make the paint thicker and give it more body so that it can be applied with a palette knife.

Thin paint and glazes will dry within a matter of minutes, while rather thicker paint will be dry within half an hour. Thick impastos will stay workable for much longer periods, as will large blobs of paint on your palette. It is when mixing small quantities of paint that the fast drying time can really become a disadvantage, as the paint may even be dry before you've finished mixing it, and paint that you mixed earlier on in a painting and would like to modify and use again will certainly be dry before you return to it. You can add a retarding medium to overcome this problem, but it's a nuisance to have to add this to every colour you mix, so the best plan is to buy a "stay wet" palette, a special disposable tear-off palette in which water from a reservoir continually seeps up to moisten the paints.

PASTELS

Pastels have been in use since the 18th century, when they were particularly fashionable in France. They are made of pure pigment and varying amounts of whiting, depending on the lightness or darkness of the colour, and bound with just enough gum to be pressed into stick form. As with watercolour, there is a prevalent belief that only pale and delicate shades can be obtained with pastels, but this is really not true; many modern pastellists produce wonderfully vivid work, and the greatest exponent of the medium, Edgar Degas, used pastels to create some of the richest colour harmonies ever seen.

As far as equipment is concerned, pastel is the simplest type of paint to use, since only paper, and the pastel sticks themselves, are needed. It's one of the most immediate of all the painting media — there are no delays while you mix colours or rinse brushes, and you don't have to wait for bits to dry before putting on the next colour. No bottles, brushes or palettes are needed, and the pastels themselves are highly transportable. It's rather like drawing, but drawing with colour.

Pastels are made in three qualities, soft, medium and hard, with soft being the easiest to use and thus the most popular. Most manufacturers label the sticks with the name of the pigment, for instance "ultramarine" or "lemon yellow," and give a number indicating the relative lightness or darkness. This is usually on a scale of 0 to 8, but manufacturers vary, and there is no standard system.

Characteristics of pastels

Unlike the "true" painting media, pastels cannot be premixed, although they can to some extent be mixed on the paper. Instead, the painter uses a range of sticks, each of a different tint, or shade, and the picture is made up of small strokes or marks of each stick. These can be laid one over another in a technique called hatching, or they can be softly blended together with the finger, a brush, a rag or a rolled stump of paper called a torchon. A great range of different pastel strokes can be

Pastels (left) call for less equipment than any other painting medium — all that is needed are the pastels themselves and some paper. There are some useful extras, however, which include a kneaded eraser for lifting out areas, a rolled paper stump (torchon) and soft brush for blending, and fixative to ensure that the pastel pigment does not smudge or fall off the paper. The choice of paper is important as it plays a part in the final design. Pastel papers are usually coloured, and have some texture to retain the grains of colour. Shown here is a selection of Ingres and Canson Mi-Teintes paper in a variety of colours. Oil pastels (right) can be done on the same paper, or on watercolour or sugar paper (top right). They are quite different from ordinary pastels — more like condensed sticks of oil paint — and can be mixed on the painting surface by "melting" with a brush or rag dipped in turpentine (or white spirit).

made, from broad sweeps using the side of the stick to fine lines or tiny dots made with a sharpened end.

Most pastellists work on coloured rather than white paper, leaving large or small areas to show through the pastel strokes, so that in effect an extra colour has been added to the palette. The paper should have a little "tooth" to catch the pigment as the stick is rubbed over it. If the paper is very coarse grained, little specks show through where the pigment has not entered the "pits," giving a lovely sparkling effect.

A disadvantage of pastels is the fragility of the picture, both when finished and when working. The pigment is so easily rubbed off the paper that it must be handled with great care. Some pastellists spray their work with fixative at various stages while working, but this can deaden the colours a little and darken the tones. A completed pastel should be stored flat or framed as soon as possible.

Oil pastels

These, although they look just like ordinary pastels, are more of a painting medium than a drawing one. They can be mixed on the paper to a much greater extent than true pastels, as the colour can be spread by dipping a rag or brush in turpentine (or white spirit). The pigment can be moved around on the paper in this way, and very subtle effects can be created by laying one colour on top of another, mixing them with turpentine, and then laying dry pastel on top of this. There is more possibility for correcting mistakes than with true pastels, as whole areas can be lifted out — as long as the paper is tough enough to stand this kind of treatment. Oil pastels are excellent for rapid outdoor sketches and colour notes, as areas of colour can be built up very quickly, and they do not require fixing. They can be used on any paper, but those specially made for pastel work are the most satisfactory, particularly the toned papers.

Cotswold Landscape by Aubrey Philips, pastel, 20×28in/50.8×71.1cm. In the sky and the fields, broad strokes of colour have been applied with the side of the stick, while the tops of the pastels have been used for the more detailed trees and buildings. A dark paper has been used, showing through as a deep grey under the light sky and a paler one under the darker foreground.

Beach Series Number 2 by Sally Strand, pastel, 63×56in/160×142cm. This artist works on a large scale, and begins her pastels by laying broad washes in watercolour. After this she begins to builds up the main areas of colour by working with the ends of many different pastel sticks so that the colours merge optically. Later, she solidifies the colours by using the sides of sticks, and after each stage she sprays the picture with fixative so that she can work over previous layers without smudging. The final stage, however, is left unfixed, so that the highlights remain bright.

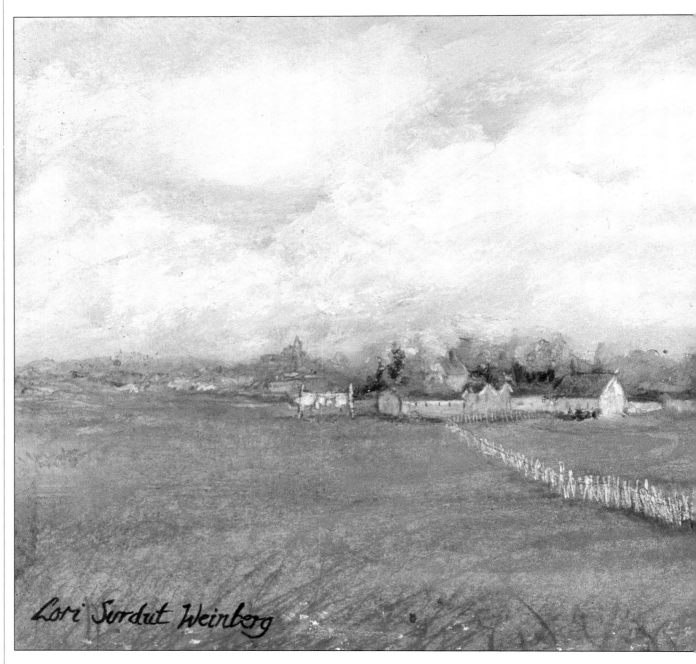

European Farm by Lori Surdut
Weinberg, oil pastel, 6×8in/15.2×
20.3cm. This artist finds oil pastels more
versatile than ordinary ones and more
satisfactory than oil paints as an outdoor
sketching medium. Here she has worked
on a textured watercolour paper, which
provides a slight "tooth," and has built up
a wide range of textures and colours by
blending the pastel colour with
turpentine in places and leaving strokes
"raw" and unblended in others.

Beech Tree in Spring by Hazel Harrison, oil pastel, 10×15in/25.4×38cm. For this picture, a limited range of no more than six colours has been used, on dark grey Ingres paper. The artist begins by lightly scribbling in the basic shapes and then spreads the pastel with a rag soaked in turpentine. Having established a tonal underpainting, she builds up each area of colour, working both dark over light and light over dark. She uses the pastel very like paint, but instead of pre-mixing on a palette, which is not possible with pastel, she blends the colours on the paper itself with brushes and cotton buds. Pastel strokes are left unblended in places to proved textural contrast.

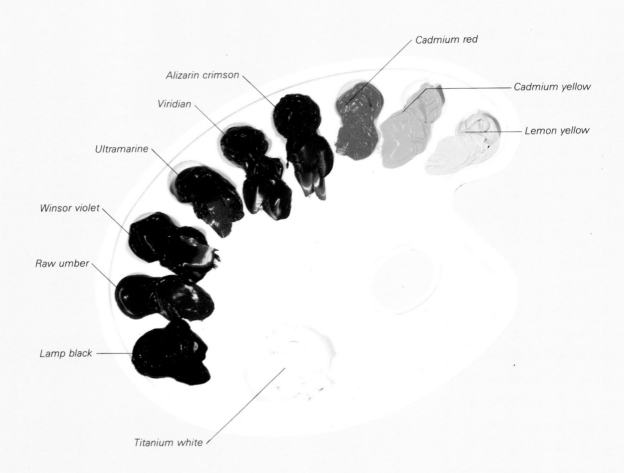

Cadmium red

Alizarin crimson

Viridian

Cadmium yellow

Ultramarine

Lemon yellow

Winsor violet

Raw umber

Lamp black

Titanium white

These ten oil colours form an adequate "starter" palette for most subjects, though you will probably find you need to add some more later. The additional colours you choose will depend to some extent on your particular interests, for instance flower painters will certainly need a wider range of reds and one or two purples, since these cannot be mixed satisfactorily, and landscape painters will probably want a bright and a dark green. More or less the same basic range can be used for all the media, though sometimes the names differ slightly, as explained in the following pages. Notice how the colours are laid out: not too near the edge, but near enough to allow plenty of space for mixing. It's also important to establish an order for the colours so that you don't confuse them when mixing . It is a good idea to keep the order of the tubes of paint in your box the same as you have on your palette. There's nothing worse than rummaging through the box hunting for a tube you need in a hurry during the course of a painting. What is more, the tubes easily become damaged, the labels fall off and chaos pretty quickly takes over.

2

THE STARTER PALETTE

This chapter gives advice on selections of colours suitable for complete beginners, and suggests some useful additions to a basic starter palette. Having too many paints, apart from being an unnecessary expense, is confusing and even counter-productive, since it would never be possible to have a paint for every hue in nature. Since all paints can be mixed to produce other colours, it would seem sensible to buy the minimum number of paints which can combine to form a maximum number of colours. Pastels, which cannot be premixed, are the exception, and require a rather larger starter palette.

There are a few paints that almost every artist agrees to be essential, including lemon yellow, alizarin crimson, yellow ochre and French ultramarine, but each artist has his or her own selection of extras, partly dictated by subject matter, partly by temperament, and partly by tradition. For instance, the selection of oil paints that I started with was simply that recommended in a book such as this. I wasn't then in a position to question the choice, but my palette has gradually evolved since that time. Some of the colours initially recommended, such as green oxide of chromium and Prussian blue, I seldom use now, but two colours I discovered for myself, Payne's grey and Winsor violet, I now find indispensable.

Some paints, such as those described as "flesh tint," are best avoided, and others are unnecessary since they simply contain mixtures of pigments which are used pure in other paints. For example, cadmium orange is a mixture of cadmium yellow and cadmium red. However, you may find one or two of these useful later on; I have found it impossible to match the intensity of cadmium green, although the ingredients stated on the tube appear to suggest a mixture of cadmium yellow and viridian. With experience you will learn to make your own selection of extras to suit your personal preferences.

WHAT HAPPENS WHEN PAINTS MIX

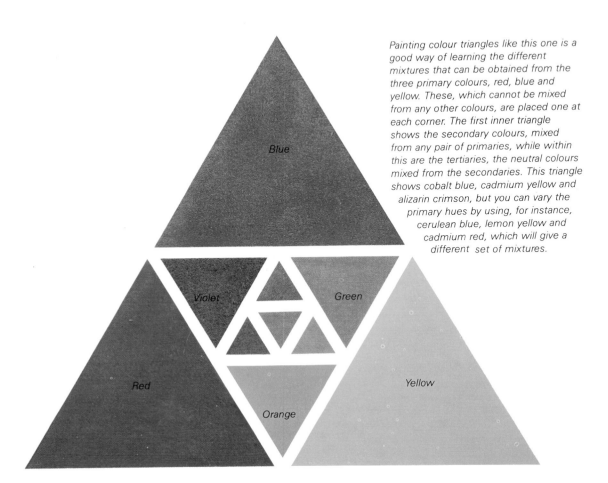

Painting colour triangles like this one is a good way of learning the different mixtures that can be obtained from the three primary colours, red, blue and yellow. These, which cannot be mixed from any other colours, are placed one at each corner. The first inner triangle shows the secondary colours, mixed from any pair of primaries, while within this are the tertiaries, the neutral colours mixed from the secondaries. This triangle shows cobalt blue, cadmium yellow and alizarin crimson, but you can vary the primary hues by using, for instance, cerulean blue, lemon yellow and cadmium red, which will give a different set of mixtures.

B efore going on to decide on a suitable palette to start with, it makes sense to examine the ways that paints mix, since what we want to do is to buy as few colours as possible and yet to obtain a wide variety of useful mixtures. When any two paints are mixed, one of three things can happen. The first is that the resulting colour is an intermediate between the two original paints; the second is that the mixture is a dark muddy colour bearing none of the character or brilliance of the originals; and the third is that the mixture is an entirely new colour apparently unrelated in hue to the originals.

The mixtures of most colours with white come into the first category, although some colours do lose their character at the same time, an example being cadmium red which quickly reduces to a dull pink. Mixing yellows with greens, or any similar or analogous colours, also produces intermediates. This is often the best way to lighten or darken bright colours without destroying them, for instance a touch of yellow will enhance the darker greens such as viridian or terre verte. Cadmium yellow can be darkened by adding yellow ochre; or cadmium red can be darkened by adding alizarin crimson. In contrast, if black is added to cadmium yellow the result is not a darker yellow, but green.

In the second category come the mixtures of complementary colours (see Chapter 6). Mix red with green and you get a muddy dark grey colour — of course this may be exactly what you want! Yellow and violet give another grey; blue and orange yet another. Black, when mixed with reds or blues, usually creates a much muddier colour than you might expect.

In the third category are certain pairs of colours which actually produce totally different hues. Red and yellow produce orange; yellow and blue produce green; blue and red produce purple. These three colours, red, yellow and blue, are called the primary colours, and are rather special in that when they are mixed in suitable combinations they can produce all the other colours, albeit in rather dubious hues and tones, but they cannot themselves be produced by mixing other colours.

But none of this is quite as simple as it sounds, because unfortunately

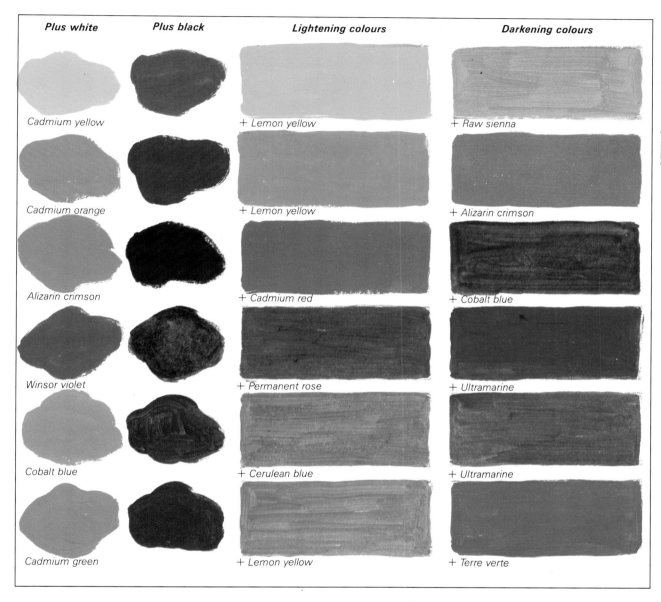

Plus white	Plus black	Lightening colours	Darkening colours
Cadmium yellow		+ Lemon yellow	+ Raw sienna
Cadmium orange		+ Lemon yellow	+ Alizarin crimson
Alizarin crimson		+ Cadmium red	+ Cobalt blue
Winsor violet		+ Permanent rose	+ Ultramarine
Cobalt blue		+ Cerulean blue	+ Ultramarine
Cadmium green		+ Lemon yellow	+ Terre verte

when any two paints are mixed the resulting colour is always darker and less brilliant than the original colours. The reason for this is that each paint effectively dilutes the other because the pigment particles of one paint are partly hidden by those of the other. Colour intensity is thus diminished for both. To the painter, a knowledge of the kind of colours to expect when different paints are mixed is tremendously important. If you don't hit on the required colour fairly quickly after mixing two or three paints, adding more colours will only increase the danger of muddying. This is especially the case with watercolour, and some artists and teachers recommend that you should mix only two colours, or three at the most. You can, of course, discover the right mixtures by trial and error during the course of a painting, but this may waste valuable time and spoil the picture as well.

This chart shows how adding white or black is not always the best way of making colours lighter or darker. For instance, adding black to yellow turns it into green, while mixing red with white can diminish the brilliance of the colour.

QUALITY AND QUANTITY

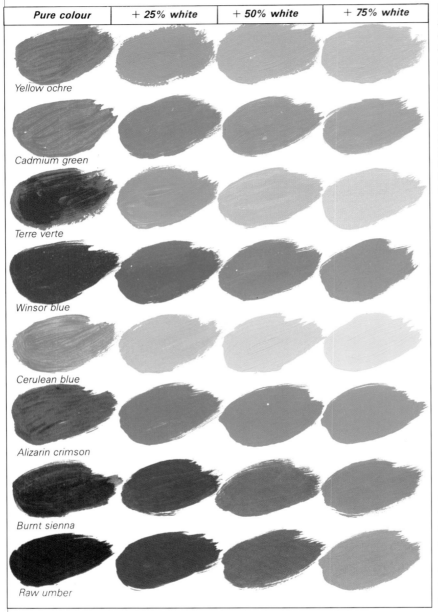

Pure colour	+ 25% white	+ 50% white	+ 75% white
Yellow ochre			
Cadmium green			
Terre verte			
Winsor blue			
Cerulean blue			
Alizarin crimson			
Burnt sienna			
Raw umber			

Tinting chart for oils *Knowing how strong — or weak — each colour is not only affects the size of tube you buy, it also saves time and effort at the mixing stage. As you can see from the chart, if you mix equal proportions of raw umber and white you will get a very pale brown. If what you actually wanted was a mid-brown, you will use up valuable paint getting the mixture right and then find you have a lot more of the colour than you needed. Conversely, some paints, such as the dark blues and bright reds, need to be mixed with a good deal of white to reduce their intensity.*

Most manufacturers produce both oil paint and watercolour in two grades, artists' and students', the latter being less expensive, as the name implies. Artists' quality paints have more pigment and less binding medium than the students', giving greater intensity of colour, and they mix better. They can also be spread further without losing their depth of colour, and in the case of oil paints are less prone to yellowing.

Some manufacturers warn that some of the colours in their students' ranges tend to fade rapidly, even in the dark, when mixed with white to form pale tints, particularly if flake white rather than titanium white is used. However, in the case of oils the students' paints can be a good choice for the beginner, and they provide an excellent means of gaining a feeling for the medium without a vast initial outlay. For watercolour, I would

recommend the very best quality from the start; using inferior paints could lead to frustration and even to an unfair dislike of the medium.

As for which manufacturer's paints to choose, you may have no choice in the matter as it could depend on what is stocked at your local art shop. Nowadays, all proprietary brand paints are of good quality, so you need not worry, but if you do have a choice, try them all eventually — you may prefer the consistency and handling of one make or the actual colour or mixing ability of another. Oil paints are always sold in tubes, and acrylics in tubes or pots, but with watercolours you have a choice between tubes, pans and half pans. There is no difference in quality between these; they are all "semi-moist" which means they will

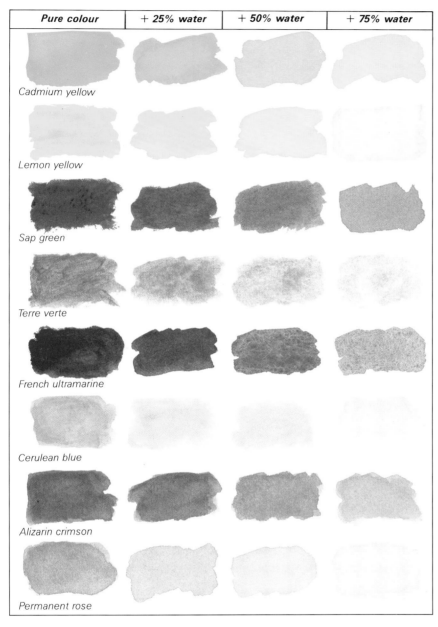

Pure colour	+ 25% water	+ 50% water	+ 75% water
Cadmium yellow			
Lemon yellow			
Sap green			
Terre verte			
French ultramarine			
Cerulean blue			
Alizarin crimson			
Permanent rose			

Tinting chart for watercolours

Watercolours also have different tinting strengths, and it's impossible to tell how dark or light a colour you've mixed up in your palette will be when applied to the paper. With practice, you will learn to estimate roughly the amount of water to add for each colour, but to start with it's a wise course to try out a mixture on a spare piece of paper before committing yourself. Let it dry first, as watercolour is considerably lighter when dry. Beginners usually add too much water because they are alarmed at how dark the colour looks when wet.

not dry out when not in use. There are also, however, some water-colours of very inferior quality mainly designed for children, which lack any brilliance whatsoever. These should be avoided, as should water-soluble poster paints. These, also mainly for children, look deceptively bright, but are so fugitive as to be of little use except for ephemeral work.

Paint quantities

It isn't really possible to recommend quantities for oil paints, except in the most general way. It would be rather like estimating the amount of wallpaper needed to decorate a room without knowing the size of the room. However, whatever the scale of your pictures, there are always some paints you'll need more of than others, the main one being white, because almost all mixtures contain white.

The tinting strength of paints varies considerably, so some paints get used up more quickly than others. Colours such as alizarin crimson, Prussian blue and phthalo-cyanine blue, cadmium yellow, cadmium red and burnt sienna are very strong, and need to be heavily diluted with white.

Tubes of these can last a long time, while those of the paints with a low tinting strength, such as raw umber, cerulean blue, yellow ochre, raw sienna and Payne's grey, go down very quickly. I suggest starting with a large tube of titanium white (115ml) and 37ml tubes of the other colours, with perhaps one or two smaller (22ml) tubes of any colour with a high tinting strength that you think you may not use often. Avoid having many small tubes — the painting may suffer because you will be nervous about using up too much paint.

THE COLOURS YOU WILL NEED

We have seen that the three primary colours, red, yellow and blue, can be mixed to produce all the other colours, so obviously these must be included in our basic palette. But if we ask in our local art shop for red, yellow and blue paint, we will be asked "Which one?" because there are so many different reds, yellows and blues to choose from. The first ones to buy must be of the brightest, most intense hues because mixing always results in loss of colour intensity. For oil, gouache and acrylic, white is another essential paint, because many colours straight out of their tubes, particularly blues and reds, are too dark for most purposes and only produce their most brilliant and characteristic colours when diluted.

When I started painting landscapes (in gouache), I used a very limited palette consisting only of cadmium scarlet, lemon yellow, French ultramarine and permanent white. I didn't even use black, relying instead on obtaining the darkest tones by mixing the scarlet with the ultramarine and a touch of yellow. However, I was soon to find that I needed colours not obtainable by mixing the three primaries, so I began to extend my palette with violet, magenta and different versions of the primary colours — alizarin crimson, cadmium yellow and cobalt blue. I also added browns (raw umber, burnt umber), yellow ochre and black.

We will now take a look at possible starter palettes for each of the different media. I have begun with oils, but because the pigments used are more or less the same in all media, the descriptions of colours — some well known and others less so — are relevant to the others as well.

The description of colours relates to artist's quality paints only, since some colours in the students' or "sketching" ranges contain mixtures of pigments.

The blue paints

If you want to buy only one blue, I would suggest French ultramarine, a strong, rich paint. Other artists might recommend the greener and slightly paler cobalt blue, but ultramarine is that bit brighter and more versatile even though a little less permanent. I always find that it mixes better than cobalt blue in that it can form a greater range of colours when combined with other paints.

Whichever one you choose at first, make yourself thoroughly familiar with it and then try the other. Later on you could buy a tube of cerulean blue. This is particularly suitable for some skies, but although a lovely rich hue, it has low colouring power. Prussian blue, a very strong greenish blue, is favoured by some painters, as is phthalocyanine blue (or simply phthalo), similar to Prussian blue, but even more intense and with a higher permanency rating. Proprietary names for it include monestial blue (Rowney) and Winsor blue (Winsor & Newton). Both these blues have high colouring strength and can be mixed with yellows to form very rich but to my mind rather synthetic-looking greens.

The yellow and brown paints

There are two bright yellows which should be included in any palette — cadmium yellow and a lemon yellow. Cadmium yellow is the warmer colour, with a hint of orange in it. It mixes with the blues to form warm yellowish greens. Lemon yellow is cooler and paler, and forms blueish greens when mixed with the blues.

Yellow ochre also has a place on most artists' palettes. It is a dark yellow verging on the browns. It has great strength and mixes well when added in small amounts. A similar colour is raw sienna, which is slightly redder than yellow ochre and less powerful, making it easier for fine adjustments when mixing.

Also available are cadmium yellow pale and cadmium yellow deep, but neither are really necessary, as both can be made, in the first case by mixing cadmium yellow with a little white, and in the second by adding a little ochre. Naples yellow, on the other hand, is a useful colour for obtaining skin tones, although it can be imitated by mixing yellow ochre with white and a tiny proportion of cadmium yellow. Other yellows include aureolin, chrome yellow and chrome lemon. These are less permanent and generally can achieve nothing which cadmium yellow or lemon yellow cannot do.

There are only two browns which I use regularly and which I recommend to start with. The first is raw umber, a versatile, slightly greenish brown ideal for dulling the blues, yellows and greens; it has a fairly low strength so is easy to mix. The second is burnt sienna, a rich reddish brown which has such colouring power that even tiny quantities added to a mixture can alter it drastically. Burnt sienna mixed with white forms a warm pink. I often use it to modify blue and white mixtures to obtain sky tones. Another useful, though not essential, brown is burnt umber, which I think of as being the "brownest" of the browns.

The red paints

The essential reds are cadmium red, a dense, opaque colour, and alizarin crimson, a deep, powerful, transparent one. Cadmium red is very brilliant, identical in colour to poppies, but it loses its identity quickly on mixing with other colours. Mixed with white, it forms a warm pink, and mixed with blue, a very muddy purple. It is at its best when used straight from the tube or either darkened with alizarin crimson or lightened with yellow ochre. Mixing it with cadmium yellow gives a brilliant orange, identical to cadmium orange, so it is unnecessary to buy an orange paint. Alizarin crimson is most useful in mixtures. I find I use it

Some blues

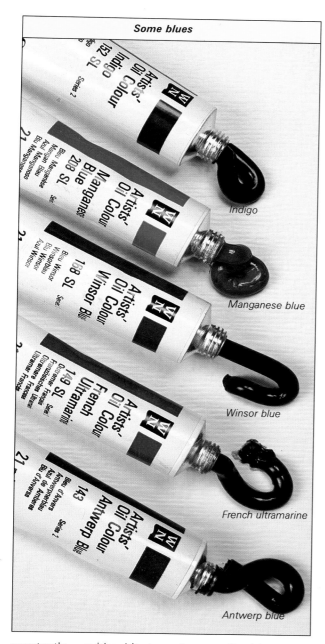

Indigo

Manganese blue

Winsor blue

French ultramarine

Antwerp blue

Some yellows

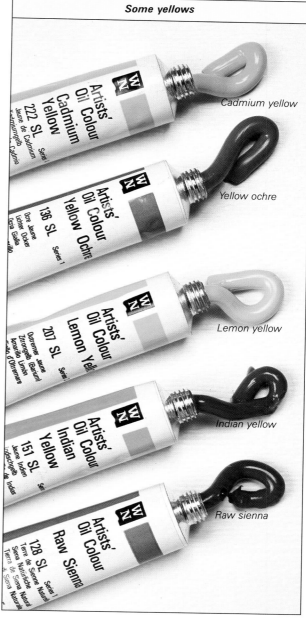

Cadmium yellow

Yellow ochre

Lemon yellow

Indian yellow

Raw sienna

constantly — with white to make a cool pink; with blues to counteract their brilliance when painting sky and sea; and combined with yellows and browns to achieve skin tones. (Alizarin is one of the slowest paints to dry on your palette, and areas of painting where it has been used will remain tacky for a long time.)

Occasionally you may find you require even more brilliance than can be given by these two reds, for instance when painting flowers. This subject may call for the use of paints like magenta (a purplish version of alizarin), carmine, the various rose colours (Rowney rose, rose doré, rose madder), geranium and perhaps vermilion. This last, an intense, warm, brilliant red, is one of the most expensive paints available, and is definitely not essential, and the carmine and rose colours must be used with caution as they are less permanent than the other reds.

The green paints

A range of greens, including most of those occurring in a natural landscape, can be mixed from yellows with either blues or black, so you may not need to buy any greens initially. However, you will soon find you want some of the brighter greens to cope with the man-made colours of clothing or paintwork and also vegetation in unusual lighting conditions such as sunlit foliage sparkling in a dark forest. Viridian is perhaps the most useful. It is dark and transparent, cool and blueish. When mixed with white, it retains its hue, giving pale, cool greens which cannot be matched by mixing yellow and blue. The opaque counterpart of

39

Some reds	Some greens

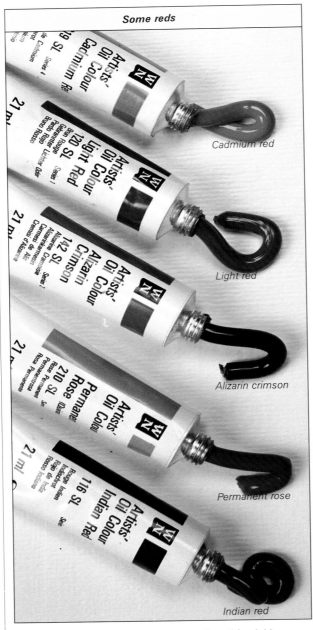

Cadmium red

Light red

Alizarin crimson

Permanent rose

Indian red

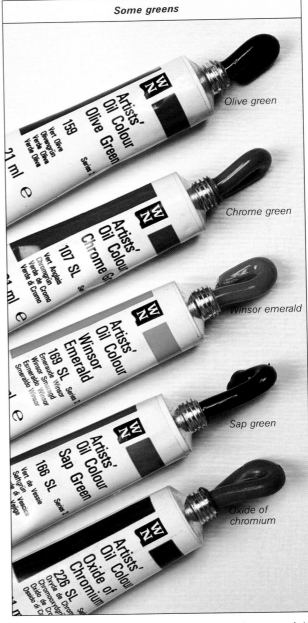

Olive green

Chrome green

Winsor emerald

Sap green

Oxide of chromium

viridian is called opaque oxide of chromium. Many painters use it a great deal for landscape.

Brighter than these two are colours like chrome green and cadmium green, both pale, yellowish greens which can be good on occasion for foliage. Another useful green is terre verte, a dull green of low colouring power. Straight from the tube, it is often identical to the dark foliage in a landscape, and I use it frequently in mixtures to modify the colours of sky, sea, foliage, flowers, skin — in fact almost any-

thing! However, it is not essential, since an identical green can be mixed from cadmium yellow, lamp black and a little ultramarine. Emerald green in the Winsor & Newton range is an artificial-looking, pale colour which does not mix well, but in some ranges it is an excellent and reliable alternative for viridian.

The purple and violet paints

Purple, like the greens, can be mixed, but only in a low intensity. The brightest violets or purples will have to be taken straight from the

tube or mixed together to yield exactly the colour you want. Cobalt violet is excellent, but I find the most useful is Winsor violet, which when mixed with rose madder, alizarin crimson or magenta, together with white, will give almost any violet or purple. It is also extremely useful for modifying the blues of the sky or sea, and for making greys with yellows, browns and greens.

The black and grey paints

I mainly use black for mixing with yellow to make greens, and for this I

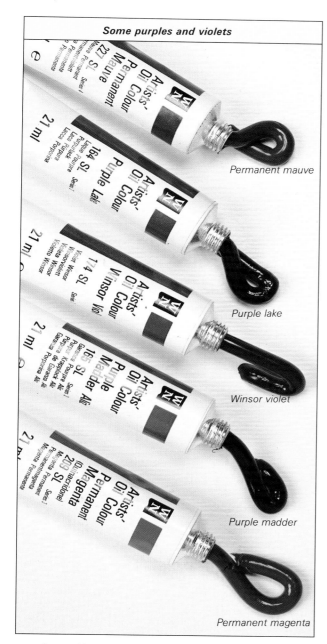

Some purples and violets

Permanent mauve

Purple lake

Winsor violet

Purple madder

Permanent magenta

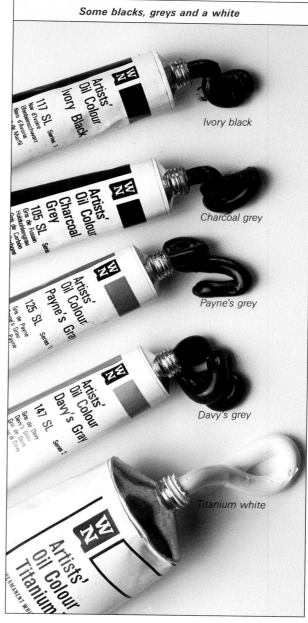

Some blacks, greys and a white

Ivory black

Charcoal grey

Payne's grey

Davy's grey

Titanium white

use lamp black, which is slightly bluer than ivory black. Black will also darken any green, but only small amounts should be used, and it destroys the vitality of other colours, so should be treated with caution. Sometimes, of course, these dark tones can be just what one needs, as when painting the very darkest shadows. In such cases, ivory black is the best one to use, as it's more neutral and a little more transparent. I also use Payne's grey a good deal. This is basically a kind of dilute black which, having relatively less strength, is very useful for modifying blues, browns and greens.

The whites
There are three whites widely available in oil colours, but to start with you really only need one — titanium white. This contains a dense pigment called titanium dioxide (which incidentally is used by food manufacturers to whiten products such as cottage cheese, icing and horseradish sauce). It is very opaque, and small quantities will whiten any other paint. It is slow drying and will remain workable for days.

Flake white, made of basic lead carbonate, is the fastest drying and most flexible of the whites, and is widely used in underpainting. It should not be used with any red paint containing beta naphthol (many of the reds in the student ranges) as it causes their colour to fade. Zinc white, which has a blue tinge, is the least opaque of the whites and the slowest drying. Because of its relative transparency, it is mostly used for mixing colours for glazes. It tends to dry to a hard brittle film.

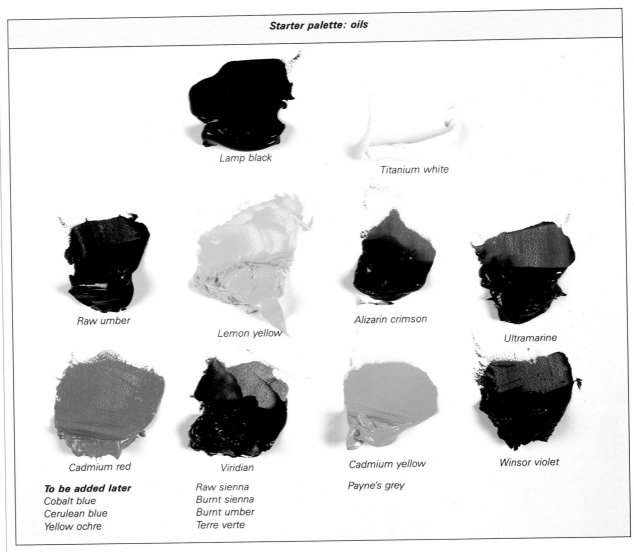

Lamp black

Titanium white

Raw umber

Lemon yellow

Alizarin crimson

Ultramarine

Cadmium red

Viridian

Cadmium yellow

Winsor violet

To be added later
Cobalt blue
Cerulean blue
Yellow ochre

Raw sienna
Burnt sienna
Burnt umber
Terre verte

Payne's grey

The box above summarizes the first tubes of oils to buy, and also lists those you might like to add later.

Watercolour

The relative strengths and character of watercolour paints are generally the same as for oils since in most cases the same pigments are used — the exceptions being the very opaque pigments such as opaque oxide of chromium, and the whites, titanium and flake white. Usually the same name is used for a colour in both oil and watercolour, but the pigments differ slightly owing to either their transparency or their ease of dispersal in the medium. Gamboge is an example of a colour which occurs only in watercolour.

Most art shops sell sets of good-quality watercolours in boxes, but these are expensive, and you may find there are far more colours than you need. I have been using a small pocket set measuring 2 × 5 inches containing eighteen quarter-pans, but some of them have hardly been used at all. The bird artist Sarah Merlen uses a tiny box in which there are twelve colours, and the 18th-century English watercolourist, Thomas Girtin, used no more than five.

A wiser course is to buy an empty box and fill it with colours of your own choice. Watercolour is sold in tubes (5ml or 8ml), pans and half-pans, the latter being probably the most popular. I suggest that you start with half-pans, and graduate to pans for any colours you find you use up quickly. If you like to work on a large scale you may prefer to buy tubes, but this means, of course that you have to have another box to keep the tubes in, which is less practical for outdoor work. On the opposite page (top) is a list of colours that I suggest makes a suitable selection to start with.

Note that white does not form part of the watercolour palette; the paler tones are achieved by allowing the paper to shine through very thin, dilute washes, while pure white areas in your picture are simply the paper left uncovered. Chinese white, however, a form of zinc white, is useful for adding highlights towards the end of the painting or for correcting small mistakes.

Gouache

Most manufacturers supply gouache (called designers' colours) in tubes, usually 14ml or 22ml, although white can be obtained in larger tubes, such as 38ml. Gou-

Starter palette: watercolours

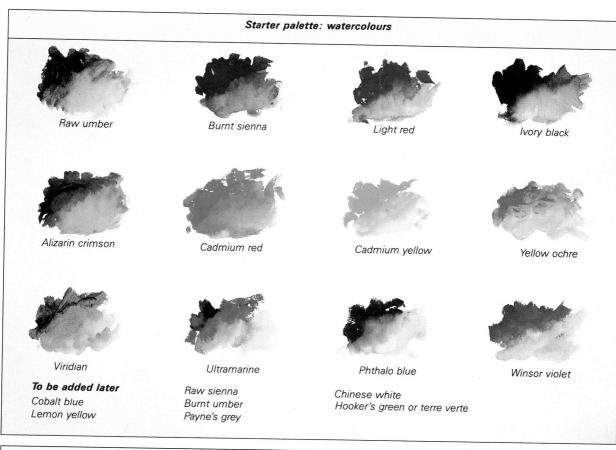

Raw umber

Burnt sienna

Light red

Ivory black

Alizarin crimson

Cadmium red

Cadmium yellow

Yellow ochre

Viridian

Ultramarine

Phthalo blue

Winsor violet

To be added later
Cobalt blue
Lemon yellow

Raw sienna
Burnt umber
Payne's grey

Chinese white
Hooker's green or terre verte

Starter palette: gouache

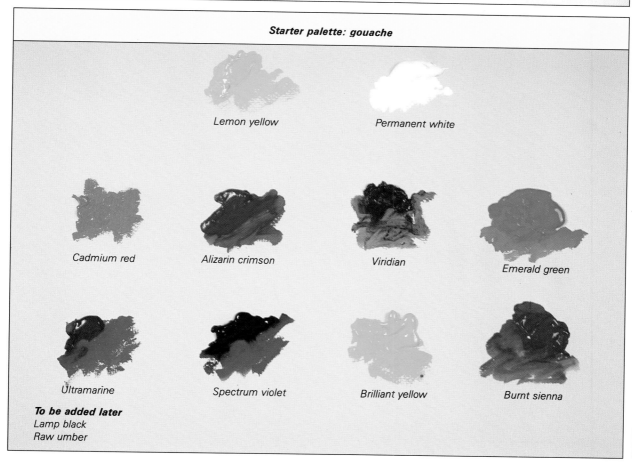

Lemon yellow

Permanent white

Cadmium red

Alizarin crimson

Viridian

Emerald green

Ultramarine

Spectrum violet

Brilliant yellow

Burnt sienna

To be added later
Lamp black
Raw umber

43

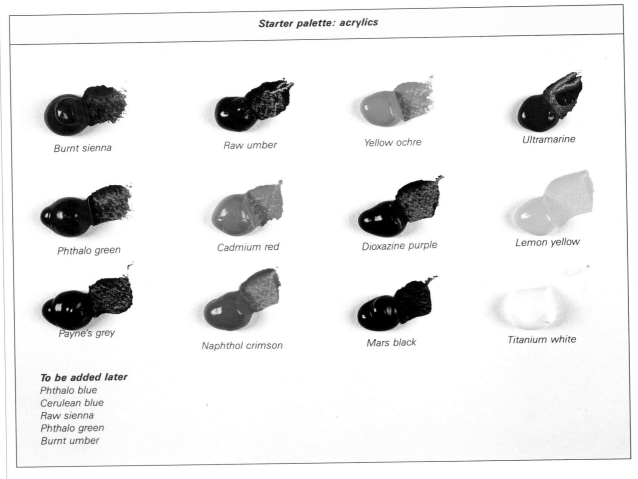

Starter palette: acrylics

Burnt sienna

Raw umber

Yellow ochre

Ultramarine

Phthalo green

Cadmium red

Dioxazine purple

Lemon yellow

Payne's grey

Naphthol crimson

Mars black

Titanium white

To be added later
Phthalo blue
Cerulean blue
Raw sienna
Phthalo green
Burnt umber

ache, being opaque and applied more thickly to the painting surface, is consumed far more rapidly than watercolour.

The names used by the various manufacturers for their gouache colours, and indeed the pigments themselves, are less consistent than their counterparts in oil or watercolour. For instance, some ranges include the cadmium colours (reds and yellows) but others do not, and the violets and purples do not always coincide with those in oil or watercolour.

Some manufacturers provide boxed sets of gouaches for beginners. For example, Rowney packs their set with eight tubes (22ml) of the following colours: white (titanium dioxide), canary, ultramarine, magenta, vermilion red, lemon yellow, brilliant green and velvet black. This palette, in fact, is not so different from those we've already looked at, since canary is similar to cadmium yellow, magenta replaces alizarin crimson, vermilion replaces cadmium red and brilliant green is simply phthalo green mixed with a yellow pigment. Since gouaches are intended for use by designers and illustrators as well as painters there are a host of colours with strange names that don't occur in the other media, such as copper brown, coral, Delft blue, peacock blue, tangerine, mushroom and so on.

However, a basic starter palette does not really differ very much from those we've already looked at. See the box on page 43 for my suggested colours.

Acrylics

The quantities required for acrylics are, on average, similar to those of oil paints (see pages 36-37), and as with oils, will really depend on the way you work and the size of your paintings. I suggest that beginners use 20ml tubes, but buy a 38ml tube of white, as this is used faster than any other paint. If you find yourself painting in thick impasto, then you could renew your tubes in a larger size (60ml or 120ml). By contrast, you may prefer to paint in layer upon layer of thin washes, in which case the smaller tubes will last a long time.

Great care must be taken to keep the insides of the caps and their screw threads clean, because if a cap is not screwed on tightly the paint will harden in the tube. If you are not going to use the paint quickly, it is inadvisable to have large tubes.

For most of the colours, the advice

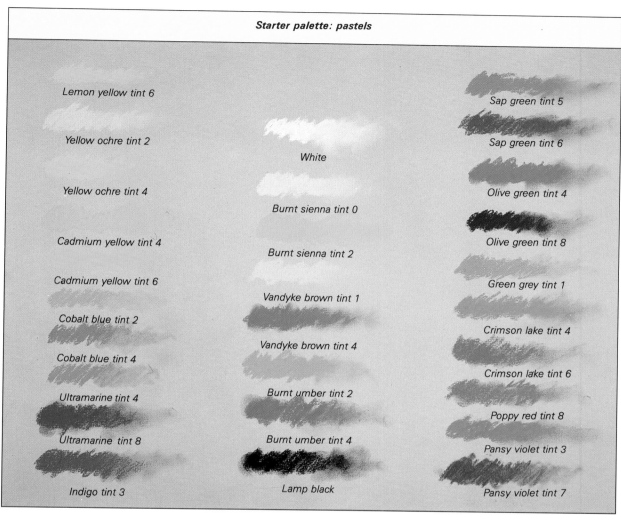

Starter palette: pastels

Lemon yellow tint 6

Yellow ochre tint 2

Yellow ochre tint 4

Cadmium yellow tint 4

Cadmium yellow tint 6

Cobalt blue tint 2

Cobalt blue tint 4

Ultramarine tint 4

Ultramarine tint 8

Indigo tint 3

White

Burnt sienna tint 0

Burnt sienna tint 2

Vandyke brown tint 1

Vandyke brown tint 4

Burnt umber tint 2

Burnt umber tint 4

Lamp black

Sap green tint 5

Sap green tint 6

Olive green tint 4

Olive green tint 8

Green grey tint 1

Crimson lake tint 4

Crimson lake tint 6

Poppy red tint 8

Pansy violet tint 3

Pansy violet tint 7

given for oils also applies here, but certain pigments used to make oil paints cannot be combined with the acrylic medium satisfactorily, so some of the well-known oil colours are not available in acrylic. These include flake white, viridian, alizarin crimson, Prussian blue and ivory black. There are also a number of pigments which are only found in acrylic paints, for example Ind-anthrene blue (a dark greenish blue); dioxazine purple or deep violet (like Winsor violet but more intense and with a higher tinting strength) and naphthol crimson (a wonderful brilliant red something like the mixture between cadmium red and alizarin crimson). A suggested basic palette is shown on the opposite page.

Pastels

Quantity and colour must be treated together here. Because pastels cannot be premixed, and only mixed on the paper to some extent, you will in time need a large range of sticks of subtly varying colours. Having said this, some pastellists prefer to limit their palette, making skilful use of a smaller range of colours. If you are just beginning and are not sure whether you will like the medium, you could try a limited selection of colours at first, with two or three tints of each. The best way to choose a selection is to buy one of the boxed sets put out by most manufacturers. The colours are largely reminiscent of those we've looked at for the other media. For example Rowney produce a set of twenty-four colours consisting of one or two tints of the colours shown above.

I suggest you avoid those boxed sets which are specifically designed for "Landscape painting" or "Portrait painting." These, by depriving you of certain colours, will tend to make you paint like everyone else owning the same boxes! Your own personality will not come through as your colours have been chosen by the manufacturer rather than yourself. You will probably want to expand your palette fairly soon and individual colours can then be added.

You may need other tints of the same colours, or more intermediate colours such as Naples yellow, cadmium red-orange, red-grey or purple-brown. As the labels have to be taken off to enable you to use the sides of the sticks, a wise course is to make a colour chart with the name of each one so that when you come to buy more you will know what to ask for.

A PERSONAL PALETTE: OILS

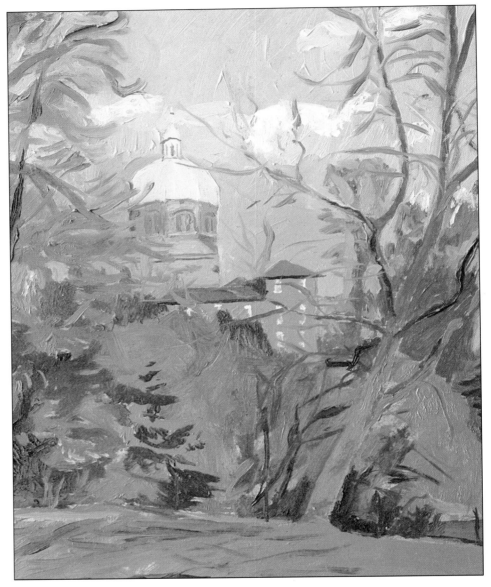

The Green Dome, Waterlow Park by
Jeremy Galton, oil, 9½×7½in/24.1×19cm.
This small oil sketch was painted with
just three additions to the ten colours
recommended here as the starter palette
for oils. The greens of the grass and the
left-hand tree are a mixture of Payne's
grey, cadmium yellow and white, while
the less natural-looking green of the
dome is viridian, lemon yellow and white.
The higher area of sky is ultramarine and
white with small touches of alizarin and
yellow ochre. One of the "extra" colours,
raw sienna, has been used unmixed
straight out of the tube for the yellowish
bush on the the extreme right.

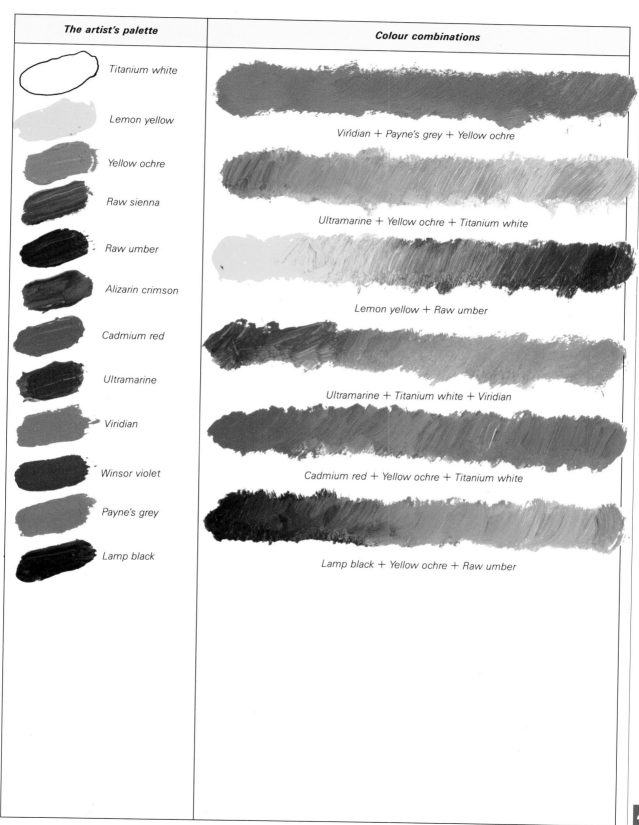

The artist's palette	Colour combinations
Titanium white	
Lemon yellow	Viridian + Payne's grey + Yellow ochre
Yellow ochre	
Raw sienna	Ultramarine + Yellow ochre + Titanium white
Raw umber	
Alizarin crimson	Lemon yellow + Raw umber
Cadmium red	
Ultramarine	Ultramarine + Titanium white + Viridian
Viridian	
Winsor violet	Cadmium red + Yellow ochre + Titanium white
Payne's grey	
Lamp black	Lamp black + Yellow ochre + Raw umber

A PERSONAL PALETTE: WATERCOLOUR

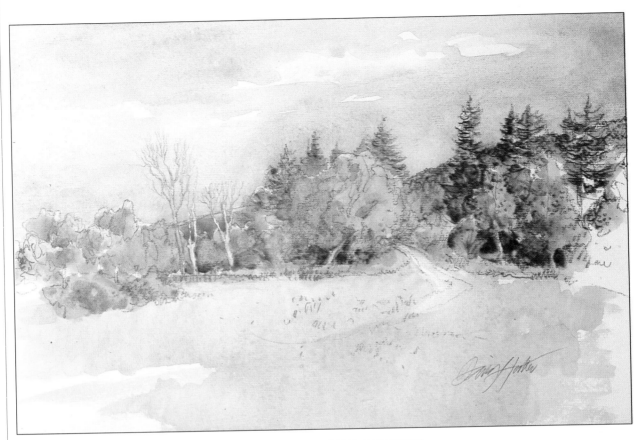

Autumn in the Jura by David Hutter, *watercolour, 11×15in/27.9×38.1cm. Watercolourists tend to use a more restricted palette than oil painters, and this subtle but colourful picture has been done with only seven colours. The paints have been applied very freely and directly, with some colours mixing wet-in-wet on the paper. In the foreground, a mixture of raw sienna and aureolin was laid down first, and then a second one, of cobalt blue, cerulean and a lighter yellow, was laid on top so that the two flooded together. Notice how the artist has used pencil as another "colour" in places, rather than painting in the outlines of branches with a fine brush.*

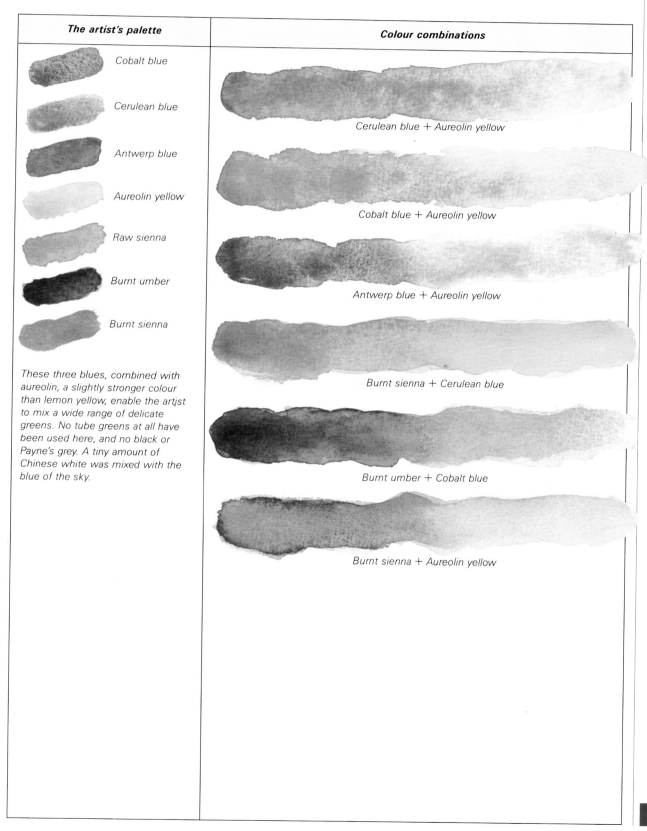

The artist's palette	Colour combinations
Cobalt blue	
Cerulean blue	Cerulean blue + Aureolin yellow
Antwerp blue	Cobalt blue + Aureolin yellow
Aureolin yellow	Antwerp blue + Aureolin yellow
Raw sienna	Burnt sienna + Cerulean blue
Burnt umber	Burnt umber + Cobalt blue
Burnt sienna	Burnt sienna + Aureolin yellow

These three blues, combined with aureolin, a slightly stronger colour than lemon yellow, enable the artist to mix a wide range of delicate greens. No tube greens at all have been used here, and no black or Payne's grey. A tiny amount of Chinese white was mixed with the blue of the sky.

A PERSONAL PALETTE: ACRYLIC

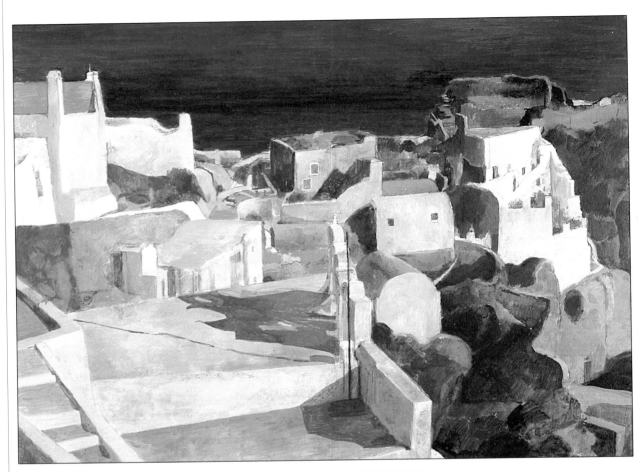

Oeia Village, Santorini *by Hazel Harrison, acrylic, 14½×19½in/36.8× 49.5cm. This painting is high in tonal contrast but has a relatively limited colour range, so did not call for an extensive palette — nine colours in all. The paint has been used quite thinly on a smooth-surfaced board, and the deepest colours have been achieved by laying washes one over the other. The sea was done by glazing phthalocyanine green over an ultramarine and black mixture, and the textures and varied off-whites of the buildings are the result of scumbling dry paint over earlier layers.*

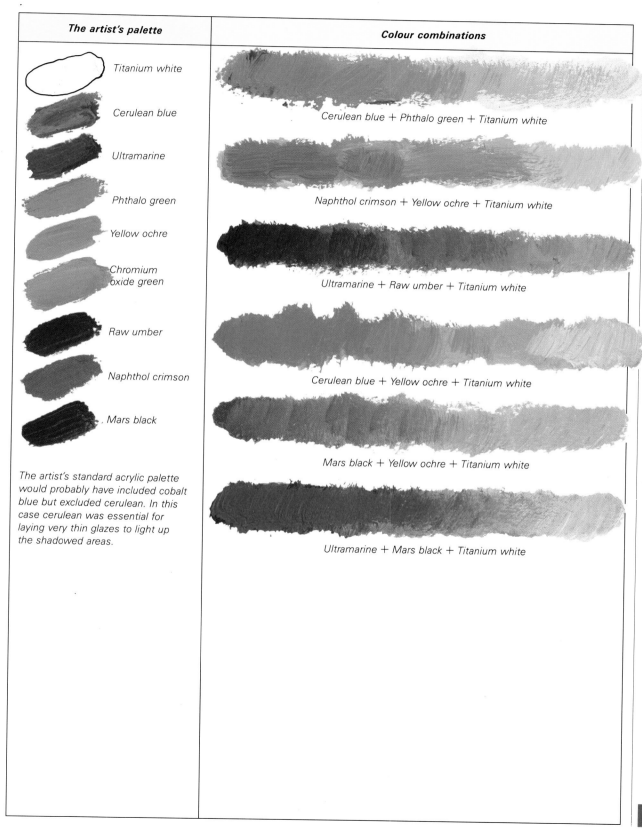

The artist's palette	Colour combinations
Titanium white	
Cerulean blue	Cerulean blue + Phthalo green + Titanium white
Ultramarine	
Phthalo green	Naphthol crimson + Yellow ochre + Titanium white
Yellow ochre	
Chromium oxide green	Ultramarine + Raw umber + Titanium white
Raw umber	
Naphthol crimson	Cerulean blue + Yellow ochre + Titanium white
Mars black	Mars black + Yellow ochre + Titanium white
	Ultramarine + Mars black + Titanium white

The artist's standard acrylic palette would probably have included cobalt blue but excluded cerulean. In this case cerulean was essential for laying very thin glazes to light up the shadowed areas.

A PERSONAL PALETTE: PASTEL

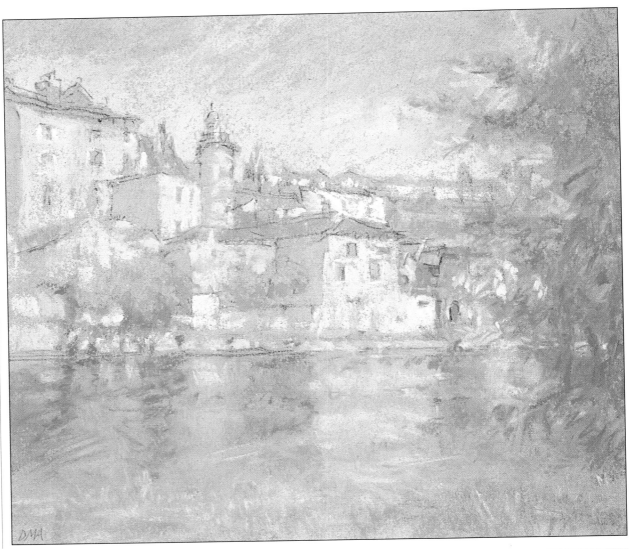

Puy-l'Eveque by Diana Armfield, pastel, 8½×9½in/21.6×24.1cm. Quite a small range of colours has been used for this delicate, luminous little picture, but the artist has given herself an extra colour by working on a warm-toned (pinkish beige) paper. The cerulean blue used for the sky thus appears warmer and mauver than it would if applied to a pure white surface. The foreground is a combination of yellow ochre, raw sienna and Naples yellow, the lighter colour laid on top of the darker ones in small strokes made with the tip of the pastel stick. A shade of ultramarine combined with cerulean and cobalt violet gives brilliance to the water, and there are touches of violet also in the shaded sides of the houses.

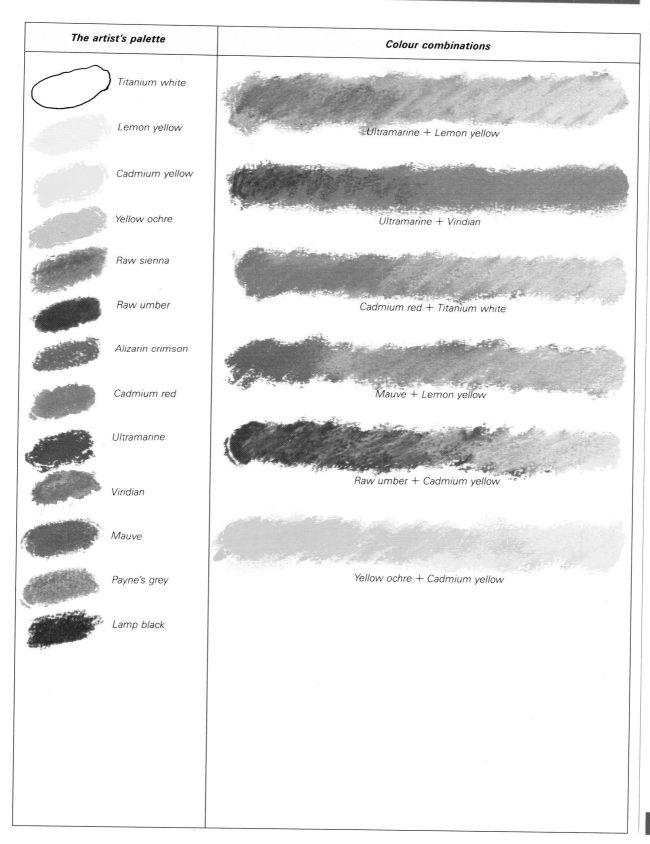

The artist's palette	Colour combinations
Titanium white	Ultramarine + Lemon yellow
Lemon yellow	Ultramarine + Viridian
Cadmium yellow	Cadmium red + Titanium white
Yellow ochre	Mauve + Lemon yellow
Raw sienna	Raw umber + Cadmium yellow
Raw umber	Yellow ochre + Cadmium yellow
Alizarin crimson	
Cadmium red	
Ultramarine	
Viridian	
Mauve	
Payne's grey	
Lamp black	

The Terrace, Richmond by William Bowyer, oil, 40×40in/101.6×101.6cm.

WHAT'S THAT COLOUR?

The colours of our surroundings are not what they seem, at any rate not to an artist. Think of a grey concrete wall. We look at it in bright sunshine, on a dull day, in the rosy light of sunset, and it's still grey. Under these three different types of illumination the light reaching our eyes is of very different composition, and yet we still see the concrete as the same colour. How can this be? The answer lies partly in the fact that we expect concrete to be grey and we cannot believe it to be anything else, but this is not the whole story. Our eye and brain respond to colour relationships rather than absolute colour. Both the concrete and its surroundings are being lit by the same light source, and as this changes, the relationship of one colour to another remains fairly constant.

Let's take another example, an orange. Hold it in your hand, and on close examination you can see that it is a uniform orange colour all over. This is known as its local colour. But now put it down in front of you and look again. You know that it really is still orange all over — but does it really look orange? To the artist, or anyone with good powers of observation, the orange in its particular setting will be an assortment of different colours, many of them being far from orange. It is the gradations of colour and tone that appear around a solid object that give us the impression of three-dimensional solidity. Our orange is receiving light from different parts of the room as well as from light reflected off other objects, so it cannot appear the same "orange" all over. It is the painter's job to observe the colour relationships in front of him or her, to find their equivalents in paint and create an equivalent of the original subject on canvas.

SEEING THE COLOURS YOU WANT TO PAINT

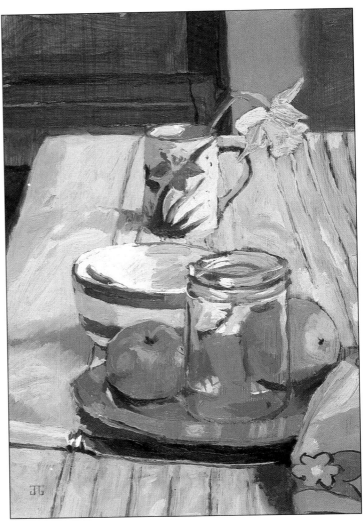

The way to do this is by clearing your mind of preconceptions, forgetting what you think is there and really looking hard and seeing. I have chosen a little oil study of textures called *Still Life with Daffodil* to illustrate the type of variety of colour and tone to look for when painting. Let us first look at the orange to the right of the picture. How much of it is painted in orange paint? Only the top right-hand quarter, and even this is in three tints of orange. Below this area are shadowy browns, and behind the glass jam jar the orange is painted in an assortment of reddish shades,

arising as reflections from the red plate on which it is standing. The red plate itself is painted in many different reds and mauves, their exact relationships giving the illusion of a flat shiny plate with a raised rim.

Mixing the right colour

As we have seen, there is no "right" colour to paint, only right colour relationships, so in a way it doesn't matter if you haven't mixed up the exact colour of the bit you're painting so long as the surrounding areas relate correctly to it. But it may matter to you because the colours are what you find most interesting

Still Life with Daffodil by *Jeremy Galton, oil, 9×6½in/22.9×16.5cm. Colour isn't what it seems. Much of the "yellow" in this daffodil is painted in greenish paint, while the "white" of the sugar bowl actually appears as an assortment of blue-grey, green-grey and even a little pure orange. The off-white tablecloth is painted in a wide range of colour mixtures.*

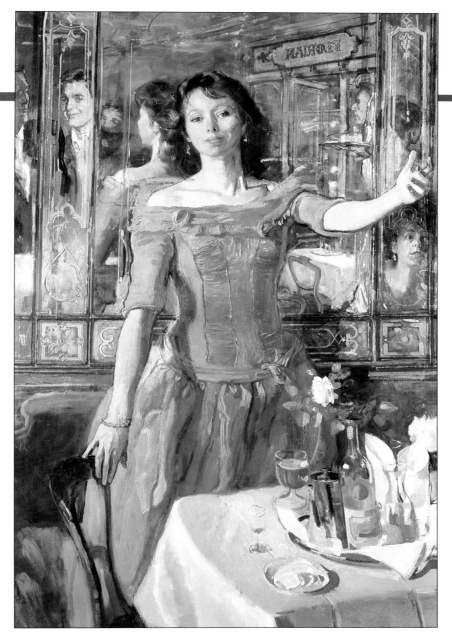

about a subject, and for the same reason many painters do strive to get as close as they can to the colours in front of them.

The act of mixing the colour you want requires the same sort of mental process as trying to sing in unison with a musical note, or seasoning a soup until it tastes just right. Mixing paint until it's just right is much more difficult though, as both tone and colour have to be adjusted, and there are far more wrong directions to take. It is a question of matching — adding a little bit more blue, now a little black and so on until you are satisfied you have the right colour. Knowing when you have the right colour can be tricky because while taking your eyes away from your subject and down to your palette you have to memorize the colour for a moment. To complicate matters, the palette is likely to be under a different light than the subject, making exact colour matching impossible. One way of doing it, however, is to simply hold the paint on your brush up to the subject so that the colours can be seen side by side. Suppose the paint is not quite yellow enough, mix in a little, bit by bit, until the colours coincide.

Jane at Florian's by John Ward, oil, 55×72in/139.7×182.9cm. As well as accurately observing and recording unexpected colours, such as the greens in the wine glass, the blues in the tablecloth and the green under the girl's jaw, the artist has also used what we could describe as "inspirational colour," notably the dazzling blue in the shaded side of the dress.

JUDGING COLOUR RELATIONSHIPS

Fishing for Mackerel, Cley Beach, *by Jeremy Galton, oil, 12×18in/ 30.5×45.7cm. Shown here is a finished painting by the author, together with a rapid oil sketch done on the spot to record the colours.*

"Unfortunately there was such a powerful wind blowing that I could hardly breathe, let alone paint a picture, but the colours of the sea and sky were so incredibly rich that I felt I had to record them, so for twenty minutes I mixed the colours which I judged to be the most important and painted them onto a small board. After two months or so, when the paint was completely dry, I returned to these 'notes' and used them as a basis for a finished painting. I had also made a drawing on a separate occasion and, although the colours then were completely different, this did not matter as I had recorded the colour in the sketch. When doing the finished painting, I matched the colours to the sketch by dabbing bits of mixed paint onto areas of the colour notes."

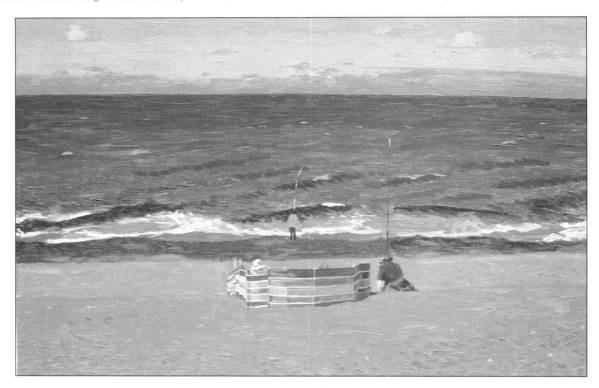

Colour relationships can be established by continually comparing your picture to your subject, and marking alterations and modifications until you judge the relationships to be satisfactory. This does require very careful observation which develops with experience. Try to look at the world around you with a painter's eye all the time, thinking which colours you could mix for that yellow-edged cloud or those interesting greenish shadows on the unlit side of someone's face. You'll learn a lot, and you may find being stuck in a traffic jam less frustrating.

A good way of analysing colour changes is to use a piece of card with a ¼-inch hole cut in it. Hold this up about a foot from you and look at an area of colour which appears at first sight to be the same all over — an orange, for example, or the cover of a sketchbook. The little square of colour you see, isolated from its neighbours, will look pretty meaningless, but now try moving the card slightly and you will begin to see variations in the colour. You will notice darker shadow areas and slight changes in colour intensity caused by reflected light or the proximity of a different-coloured object. By taking one area of colour out of context you are able to see what is really happening in terms of colour instead of simply what you expect. You don't have to use a piece of card — your fist with a little hole between the fingers will do as well.

Rydal Water by Moira Clinch, watercolour, 28×20in/71×50.8cm. This artist works in watercolour, but often uses crayons to record her on-the-spot impressions.

"My watercolours are fairly large, and I'm a slow worker, so I usually do the actual painting in the studio, from sketches, notes and sometimes a photograph. Coloured pencils are a handy sketching medium, and I tend to carry them around with me, sometimes making this kind of colour notation in the car if the weather is cold. Here I've put down a general impression of the colours, but as pencils are a cruder medium than watercolour I like to make written notes as well. The most important things to note in this case were the direction and quality of the light, both of which radically affect the choice of colours for the finished painting."

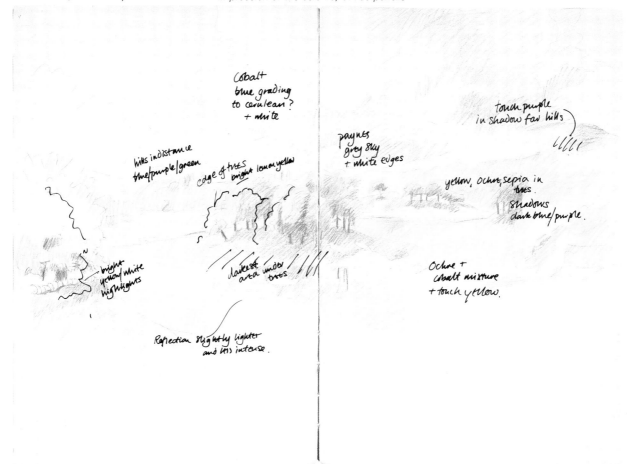

Making colour notes

On these pages we show some artists' own systems for making colour notes so that they can recreate a scene in the studio. You may remember the general impression of a colour, but no one can recall the subtle variations, so if you're out looking for a likely landscape subject try to jot down some impressions on a rough pencil sketch. This can be done in words, for instance "sky very dark blue-grey, mixture of Payne's grey and ultramarine," or "green very blue, perhaps viridian and cobalt blue." If you have paints, pastels, or even crayons with you, make some quick visual notes there and then, trying out various combinations until you are satisfied.

The Sunshine Stakes, Weymouth by Arthur Maderson, oil, 48×48in/ 122×122cm. Every artist develops his or her own method of recording the essentials of a scene which can be used as a trigger for a painting done later in the studio. Here Arthur Maderson uses nothing more sophisticated than a ball-point pen to jot down written colour notes. "I am fascinated by the quality of the light at the end of the day — anywhere between late afternoon and dusk. Since the light changes so rapidly then, I rarely paint on-the-spot. Instead, I take photographs and make rapid sketches on which I scribble colour notes in my own personal 'shorthand'. I tend to favour using associations of colours, which somehow trigger a quite specific value and textural quality. 'Ripe damson' tells me more than simply saying 'dark red', for instance. 'Mouldy lead' gives me variations on a luminous world of pale viridian and blue. I also try at this stage to establish a strong and simple pattern of light and dark values, which will hold the picture together."

Low Tide, Charmouth by Hazel Harrison, oil, 16×20in/40.6×50.8cm. Oil pastels have been used here to record the colours and light effects in a rapid on-the-spot sketch.

"I like oil pastels as a sketching medium, particularly if the finished painting is to be done in oils, as the two media are similar enough to give the same sort of effect. Personally, I never find making watercolour sketches for an oil painting quite satisfactory, and this subject particularly seemed to demand an opaque medium with a good deal of white. For the light areas in the sky I simply laid down a layer of very pale grey and then worked other colours into it with a brush dipped in white spirit. The beauty of oil pastel is that a sketch like this can be done very quickly — this one took no longer than half an hour."

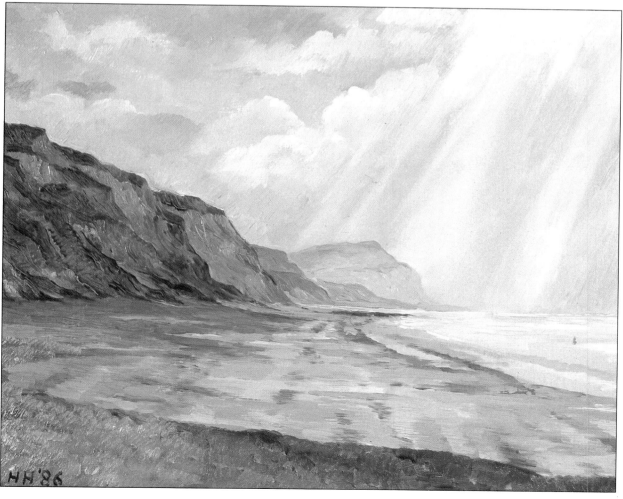

WHEN TO DECIDE ON THE FINAL COLOURS

1 This painting has been started in monochrome, a method which was standard up to the mid-19th century and which many artists still find the best way of working. The idea is to establish the broad areas of light and dark and all the basic forms before any colour is put on, thus providing a complete "map" of the lightness and darkness of each colour.

2 The next step is to paint the brilliant red and blue of background and foreground, because all the smaller areas of colour, such as those of the fruit, bottle and jug, must relate to these. The big areas of vivid colour can be modified later in relation to the rest of the painting.

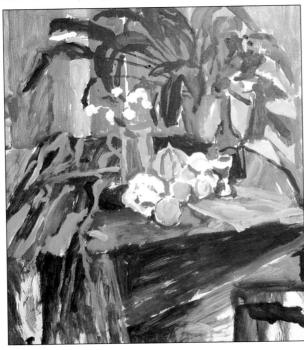

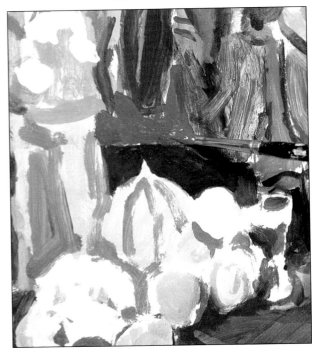

Traditionally, both in oil and watercolour, the artist would first establish the tonal relationships of a painting in broad areas of thin wash, or a pencil or charcoal drawing. In oils, an earth colour such as terre verte, raw umber or sometimes ultramarine diluted with turpentine would be used to lay out the darker areas, thus producing a rough monochrome image. Bit by bit more colour would be added, and the painter would gradually build up a network of tone and colour gradations and contrasts, continually approaching closer to an equivalent of the subject in paint. Towards the end of this process the final adjustments would be made.

Some artists still work in this way, but it is by no means essential — you can aim for the final colours immediately. In pastel, every mark on the paper must be final because it cannot be erased satisfactorily or drawn over — a pastellist must plan the picture carefully in advance. Watercolour painters also now tend to start with the final colours, or paler versions of them, finding that this approach gives a fresher and more immediate look to a picture. This applies equally to oil; a free, spontaneous painting can be the result of treating every brushstroke as the final one, as the Impressionists did. In many of my own paintings illustrated in this book there has been little or no underpainting, the pitch of the painting being established from the start.

Watercolour differs from oil in that, although both bright and subtle colours can be achieved, accurate colour equivalents are not always possible. Too much mixing destroys watercolour, as does a succession of too many washes laid on top of each other. Watercolour relies more on tonal relationships, which are gradually developed throughout the execution of the painting.

The advantage of acrylics, when used thin, as described in Chapter 1, is that layer upon layer can be added until the colour you want is arrived at. Of course they can also be used opaque, and treated in much the same way as oils.

3 Having painted the mid-green of the jug and the melon beside it, the darkest colours can now be painted in. Touches of white are added to the dark green bottle, to be toned down if they are found to be too bright.

4 The blue of the drapery needs to be given some modelling, and it seems too uniform in colour, so some touches of lighter blue and violet are added. Notice how close the finished painting is to the monochrome "beginning" in terms of

tone. The artist has not had to waste time balancing dark, light and medium colours against one another because he was able to follow the guidelines he set himself in the first stage.

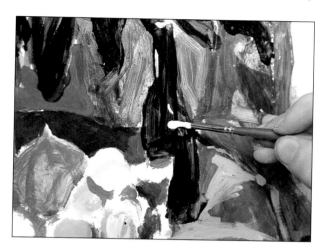

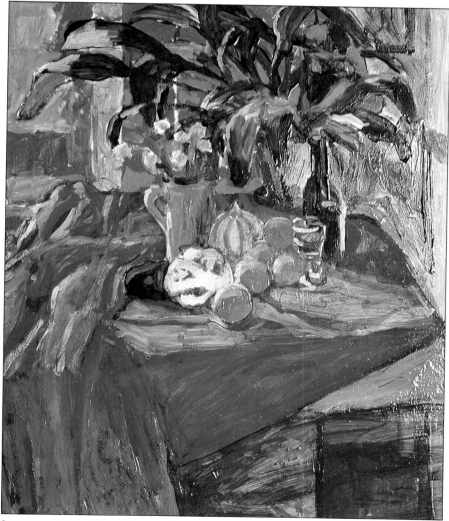

Still Life with Aspidistra by James Nairn, oil, 24×18in/61×45.7cm.

A METHOD FOR DIRECT COLOUR MATCHING

Provençal Village, Lacoste by Jeremy Galton, oil, 7×8in/17.8×20.3cm. This picture was done on the spot in two hours, using the artist's special method of direct colour matching. In order to demonstrate the method, he has agreed to recreate part of the painting, using the same system. When he painted the original, he was, of course, matching the colours on his brush to the actual landscape, while here he is matching them to the original painting. The process, however, is exactly the same.

I have evolved my own system for a direct matching of colours and tones, which may help a beginner to make accurate observations. It avoids the necessity of repeatedly looking up at the subject and down at the palette. To explain what I mean I describe on these pages how I mixed some of the colours for a painting I did in southern France. I began with the sky, because once one area of a painting is correct in tone and colour the others can be balanced against it. In this case the sky was the "key." I first took some white paint on my brush, then added a little cobalt blue to it. By holding the brush up to the area of sky in question I could see by direct comparison that the paint was both far too blue and too light in tone. I continued to make adjustments, adding touches of raw umber and other colours until the colour matched so perfectly that the paint was virtually indistinguishable from the relevant bit of sky.

The beauty of the method is that it establishes the correct tonal key. When I began on the buildings I found that the paint needed here was close to pure white, but even the whitewash was not as white as titanium white straight out of the tube, and I had to add minute proportions of raw sienna and Payne's grey. Beginners are generally very frightened of using sharply contrasting tones, and I admit that I frequently have difficulty establishing a tonal key when conditions prevent me from using this method.

Shadows always present a problem. Their colours are elusive because they are often far removed from what we expect. Shadows falling on a sunlit path may be blue or violet, not the dark brown or grey which we may suppose. The reason for this is that while the sun is shining on parts of a scene, the areas in shade are receiving only the blue light from the sky. Don't be afraid of the colour you arrive at using the matching method — once all the surrounding colours have been painted in, they will work together and you'll see that the mixtures obtained in this way were right.

Other colour-matching methods

The main drawback with the direct method is that it can only work if the lighting conditions are just right: both the subject and your brush and paint must be illuminated by the same light source. For example, if bright sunshine is lighting a landscape then your brush must also be lit by the sun. If your paint-laden brush is in shade and held up to a sunlit landscape, the paint will look black against the landscape. Similarly, if you are painting into the sun, the brush and paint will be merely a silhouette. There are also certain precautions to take. While holding the brush up in front of you, its angle

1 Just as I did when painting the real landscape, I begin by mixing white with a little cobalt blue, on the assumption that the sky is quite pale. I hold the brush up to the colour I am matching and find that it is much too light and blue. From experience I know that I can successfully modify it with Payne's grey and raw umber, so I mix in a little of both.

2 Holding up the brush again, it is obvious that the sky is more violet than the paint. Something is needed to achieve the correct adjustment. The options include alizarin crimson, burnt sienna or Winsor violet. I choose the latter which, with one or two more fine adjustments, gives a colour which perfectly matches the sky at the top of the picture.

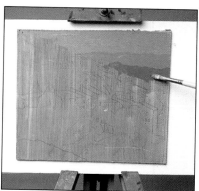

3 Sky is often much darker than one thinks. Painting on a toned ground helps here — a white background would show up these sky colours as being unbelievably dark. Now I am painting in the distant hills with the same paint I used for the bank of clouds but with a small addition of Payne's grey, ultramarine and raw umber.

4 To make more space for mixing on my small travelling palette, I push aside the mixtures made for the sky and distant hills for possible use later on. I then block in large areas of foliage with green made from mixtures of ultramarine, Payne's grey and cadmium yellow, in places using terre verte straight from the tube.

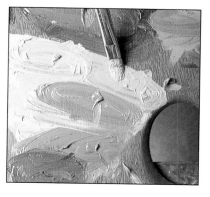

5 Now the darkest areas have been established I have a "key" for the colours and tones of the houses, and I find that the "whitest" house is surprisingly dark. The pinkish roofs are based on raw sienna and white modified with varying amounts of cobalt blue, raw umber and alizarin crimson. The bluer shades on the walls are obtained partly from my reserved sky mixtures.

6 When using the direct matching method it is important to have complete trust in it — never try to alter your colours because you don't believe that what you see is true. Once a number of adjacent colours have been painted, you will find that their inter-relationships are perfectly correct.

of tilt is important. If this is varied the apparent colour of the paint on the brush changes, so this angle must be kept the same throughout.

Unfortunately the method only really works well for oil paints. Acrylics will tend to dry before you have mixed the colour you want, especially if it's a difficult colour and is taking a long time to match, and both gouache and watercolour are virtually invisible on a brown sable brush. However, a similar method can be used for the other media, which is that of mixing up a little paint on the edge of a small piece of paper and holding it up to the subject in the same way. This may not give you a perfect match, as it is less precise than the method just described, but it certainly helps you to judge tones, as you can see immediately if the colour you have mixed is much too light or much too dark. It will also give you a very good idea of whether a green is too yellow or a pink not warm enough, especially if you can hold your mixed paint close to the subject, as when painting flowers or a still life.

65

Cattle in a Poppy Field by Arthur Maderson, oil, 32×45in/81.2×114.3cm.

4
MIXING
WITHOUT MUDDYING

Most of us must have noticed in our childhood how brightly coloured strips of modelling clay quickly become an unpleasant muddy grey colour when mixed up together. Exactly the same thing happens with paints if they are not handled carefully. Some paints mix better than others, and some colours mix very well with one paint in a different colour group but not with another. Inexperienced painters tend to muddy their colours because they don't know which ones to start with and thus mix many different paints together in the hope that it will come out right in the end. Usually, though, it doesn't, so in this chapter I give some hints about which colours make the best mixtures, and which ones can be used unmixed, straight from the tube — you don't always have to mix.

USING UNMIXED COLOUR

The problem of how to avoid muddying can sometimes be solved simply by using your colours straight from the tube, but obviously this can only be effective in some areas of a painting or the result would be garish and untrue to nature. Also, many beginners seem to make muddy messes even in this way! It is, of course, the combination of colours that is the crucial factor. In oils, the unmixed use of dark transparent paints — ultramarine, alizarin crimson and viridian — usually seems to result in a gloomy, depressing picture, whereas mixing these colours with just a little white not only lightens them but also enormously enriches their quality.

Frederick Gore's painting shown here is a splendid example of the way that pure, bright colours can be used to great effect with the minimum of mixing. The cadmium yellow flowers and the ultramarine in the lower half of the painting are largely unmixed, although some of the blue probably has a little white in it in parts. The cadmium red patch in the middle is mixed with varying amounts of white. The green olive trees in the red fields are painted in viridian or oxide of chromium with, again, varying amounts of white. There are a number of different greens in the distant landscape, some of the fields being mixtures of ultramarine and cadmium yellow.

Although there is some mixing of paints, it is kept to a minimum, and the effect of pure colours gives a wonderful spontaneity and vitality to the picture. When working in this way, the colours must be chosen carefully or chaos will ensue. Gore has established a colour key of yellow and blue, "spicing" the picture with a large patch of red — a trio of colours creating in effect a kind of major chord, to borrow a musical

Val d'Entre Conque by Frederick Gore, oil, 36½×50in/92.7×127cm. One way to avoid muddying colours is to keep mixing to a mimimum, but in inexperienced hands this can result in a garish and unharmonious picture. Here extremely skilful use has been made of cadmium red, cadmium yellow and ultramarine, largely unmixed and straight out of the tube, establishing an overall colour key of red, yellow and blue. Notice how the yellow flowers stand out against their blue and purple background.

term. In the past I also used to like painting with the minimum of mixing, often using colours which I never touch now.

Another picture which has bold areas of pure colour is Frances Treanor's pastel, *Bunch of Flowers,* in which the cool background is done in a single turquoise colour which has been loosely applied in strokes forming little fan shapes over the entire surface. Bare patches of very dark ground show through, giving texture and variety to the colour. Letting the colour of the paper show through is a technique much used in

pastel, where colours cannot be mixed on a palette as they can with oils. If a single unmixed colour is used for a large area such as this it is important to break it up in a way that echoes the treatment of the rest of the picture, otherwise the separate areas will not relate to one another. Imagine what this painting would look like if the turquoise background had been painted smoothly and uniformly — the vase and flowers would look as if they had been cut out and placed on a turquoise background.

Bunch of Flowers by Frances Treanor, pastel, 26×38in/66×96.5cm. This lively pastel is made up of large and small areas of pure colour which, combined with the bold treatment, give it a strong feeling of vigour and excitement. No muddy colours here, although the very dark paper the artist has used has been left to show in shimmering patches throughout the picture surface.

WHICH PAINT COLOURS TO MIX

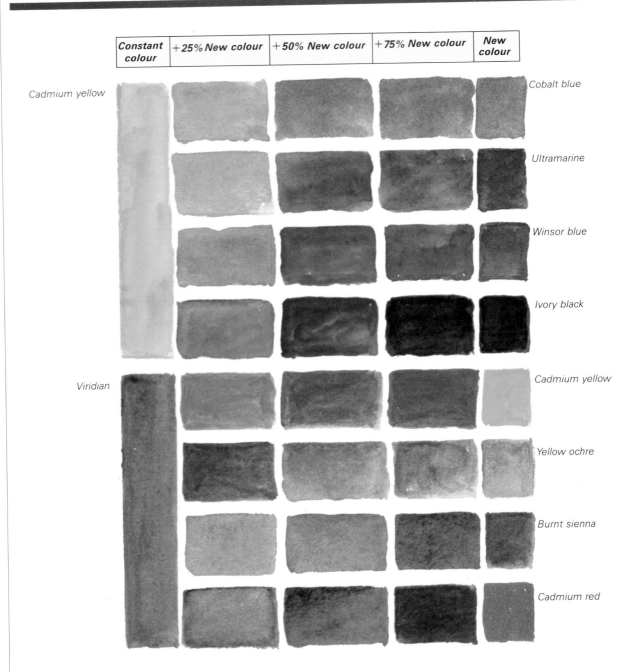

Constant colour	+25% New colour	+50% New colour	+75% New colour	New colour

Cadmium yellow — Cobalt blue, Ultramarine, Winsor blue, Ivory black

Viridian — Cadmium yellow, Yellow ochre, Burnt sienna, Cadmium red

We touched on mixtures of the primary colours in Chapter 2, and explained that when two primary colours are mixed the result is a secondary colour. For example blue and red, both primaries, make purple, but this does not tell us which blue and which red make the best purple for our needs. We have also seen that when complementary colours, such as red and green, are mixed we get a muddy grey, so obviously we must avoid near-complementaries for our purple. Cobalt blue has a hint of green in it, and when mixed with red it produces a greyish purple. To make a purer purple you'll need to choose a less green blue, preferably one with a hint of purple. Ultramarine is the best bet. Next we must consider the red. A bright orange-red, such as

Greens The range of greens that can be mixed is almost limitless. In the top part of the chart we show a single yellow, cadmium, mixed with a range of blues to produce greens. Varying the proportion of blue and yellow in each mixture increases the range still further. Tube greens can be modified with other colours on your palette. Here we show viridian-based mixtures, but you can try the same exercise with other greens, such as sap green or terre verte.

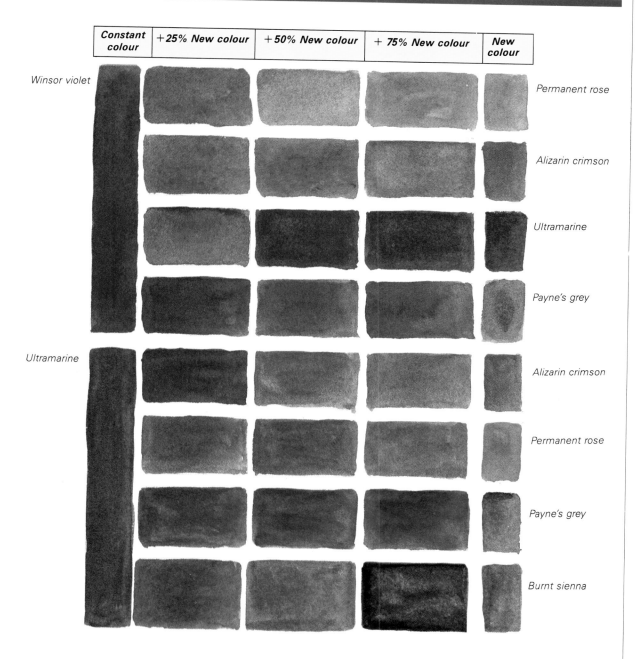

	Constant colour	+25% New colour	+50% New colour	+75% New colour	New colour	
Winsor violet						Permanent rose
						Alizarin crimson
						Ultramarine
						Payne's grey
Ultramarine						Alizarin crimson
						Permanent rose
						Payne's grey
						Burnt sienna

cadmium scarlet, will muddy the blue, as orange and blue are complementaries, so this won't produce a satisfactory purple. The best red is the one nearest to purple: alizarin crimson is a good choice, and magenta or rose even better. Some blue and red mixtures are initially very dark, but a small addition of white will bring out the character without destroying the hue.

The more transparent a paint is the better it mixes because the pigment particles in the mixture do not get hidden behind each other so thoroughly. This is another reason why the opaque cadmium red is less good at mixing than the transparent alizarin, magenta or rose. Cobalt blue is also slightly less transparent than ultramarine, so it is not such a good mixer.

Pinks, purples and blues *Really brilliant violets and magentas cannot be mixed from other pigments, which is why flower painters like to have a good range of these colours, which they can then modify as necessary. However, it is possible to use these brilliant colours as a base for mixing more subtle, muted shades. Here, Winsor violet and French ultramarine have been modified with other palette colours to demonstrate the vast range of pinks, purples and blues that can be created.*

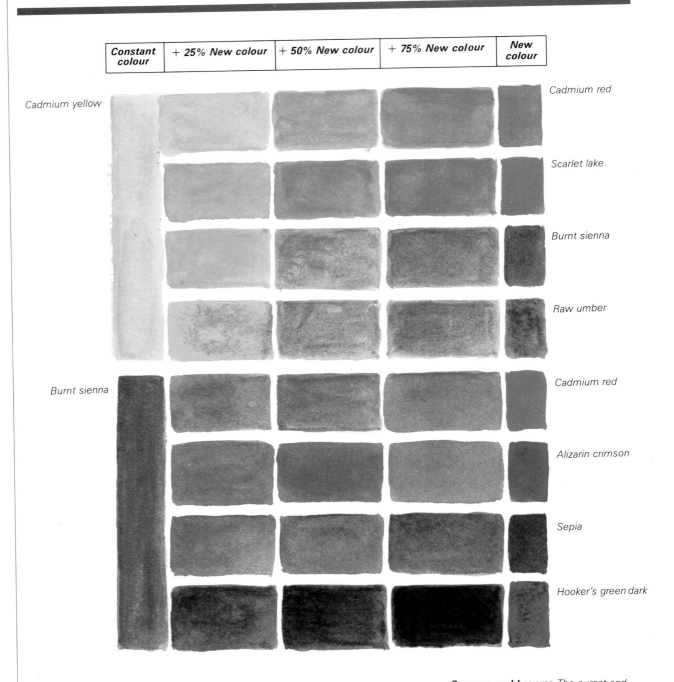

Constant colour	+ 25% New colour	+ 50% New colour	+ 75% New colour	New colour

Cadmium yellow — Cadmium red

Scarlet lake

Burnt sienna

Raw umber

Burnt sienna — Cadmium red

Alizarin crimson

Sepia

Hooker's green dark

To mix the brightest possible green from other colours in your palette, you should choose the greenest blue you have — perhaps phthalocyanine blue or Prussian blue. Cobalt blue, although a little greener than ultramarine, is less good for rich greens as is it more opaque. Cerulean has low tinting power, but it is useful for making cool, blueish greens. There are many yellows to choose from:

cadmium yellow and yellow ochre both make warm greens, and lemon yellow the cooler, bluer ones. As with the purples described above, a little white may need to be added to lighten some blue and yellow mixtures. A vibrant, rich olive green can also be made by mixing cadmium yellow or yellow ochre with lamp black. I find I use black mainly for this purpose, as this kind of green cannot

Oranges and browns The purest and most brilliant orange is made from cadmium red and cadmium yellow, which gives almost exactly the same colour as that sold in the tube under the name of cadmium orange. Rich red-browns can be made by modifying an earth colour such as burnt sienna with various reds; dark browns are achieved by mixing earth colours with greens or greys.

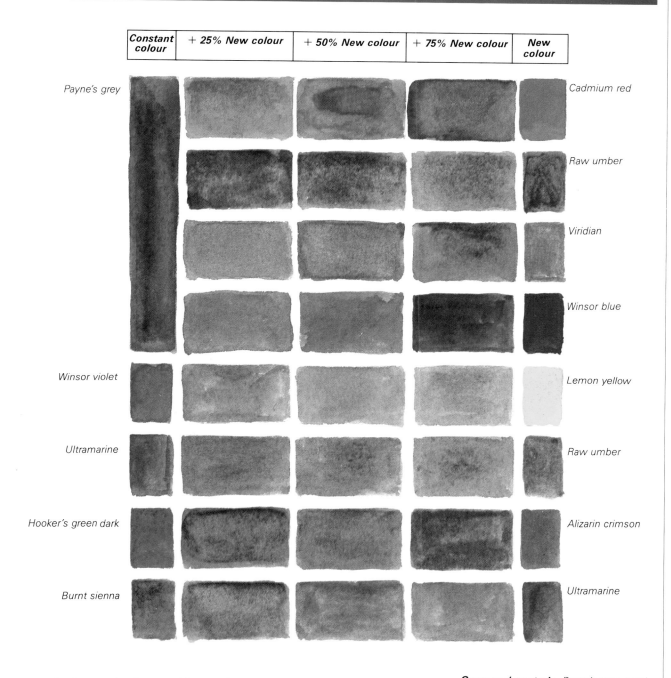

	Constant colour	+ 25% New colour	+ 50% New colour	+ 75% New colour	New colour	
Payne's grey						Cadmium red
						Raw umber
						Viridian
						Winsor blue
Winsor violet						Lemon yellow
Ultramarine						Raw umber
Hooker's green dark						Alizarin crimson
Burnt sienna						Ultramarine

really be made from a blue and yellow mixture.

Orange is easy to make by mixing cadmium red and cadmium yellow. Using the bluer reds, such as alizarin or magenta or the bluer yellows such as lemon yellow produces quieter, less orange hues, again because blue and orange are complementaries.

So far I have discussed the various secondary colours in terms of their brightness and intensity, but "muddy" or subtle colours also have their uses. Bright, clear colours can be offset and enhanced by areas of darker or more muted colour, while too many pure colours of different hues can often fight with one another so that the brilliance of each is lessened.

Greys and neutrals Payne's grey, used in the upper half of this chart, is a good base for the cooler neutral colours, such as those found in shadows and cloudy skies. Another method of achieving interesting greys and neutral shades is by mixing two complementaries (red and green, violet and yellow, blue and orange) or near-complementaries such as blue and brown. Pastellists often make use of this, toning down a too-bright area of colour by overlaying strokes of its complementary.

73

THE MECHANICS OF MIXING PAINTS

Mixing by palette knife

Mixing oil or acrylic paint can be hard work, particularly when you're using large quantities. In such cases it often helps to use a palette knife — and you avoid damaging your brushes. With a scoop and slide action, you can mix paints fast. A palette knife spreads the paint over a large area so it is best to use a big palette.

Mixing oils or acrylics with a brush

When working fast and mixing small quantities of paint a brush is more convenient to use than a palette knife. Use gentle sweeping and rotary motions of the brush to minimize excessive wear and tear on the bristles. When you have finished with a particular colour, clean the brush thoroughly so that you don't contaminate a new colour. With acrylic paint it is essential to clean each brush immediately after use as this medium dries so quickly. To clean a brush, wipe off as much paint as possible onto newspaper or rag first, followed by a thorough rinse in white spirit (for oil paint) or water (for acrylic paint). Check that it's clean by finally dabbing it onto a rag.

Oil paints and acrylics, with their thick consistencies, require a relatively large amount of physical effort to mix them. They can be mixed with either a brush or a palette knife. Much of the wear on brushes occurs during this mixing process and for this reason some painters mix paints only with a palette knife. However, I find this an awkward procedure, and always prefer to mix with a bristle brush — although not necessarily the brush I'm using for painting. I try to mix with old, worn brushes, but during the course of a painting often

forget to use them, thus slowly ruining my good brushes! I do make sure, however, that I never mix with sable brushes — these are quickly spoilt and are very expensive to replace. What happens to bristle brushes is that the outer hairs get shorter and shorter, the brush assuming an increasingly pointed shape. The hairs of sables and other soft-haired brushes quickly become splayed, broken and unusable. Nylon brushes are cheap and adequate for painting with, but when used for mixing they immediately lose their shape and become a

twisted tangle. When mixing acrylic paints, remember to rinse the brush immediately after use, or else the paint hardens and the brush is impossible to restore.

Watercolour and gouache are much thinner in consistency. Only sable or soft-haired brushes are used for these media and mixing is carried out using these brushes. Care should be taken to avoid back-bending of the hairs, as this shortens their life considerably.

As for the palette, it will gradually become covered with your mixtures as the painting progresses,

Watercolour

Watercolour washes need to be mixed in larger quantities than you think. It is always surprising how fast they are used up. You can use almost any non-absorbent white surface as a palette for watercolour or gouache, including plastic or china crockery. Take care that the colours don't run into each other on the palette (pure tube colours can be put in separate pots) and also that you use a well-cleaned brush each time a new colour is used. In contrast, it is an advantage to keep paint on the brush at the end of a day's painting as the gum binder in watercolour helps the brush to retain its shape. Remember to rinse it clean before using it again.

Glazing in oils

Since a glaze is transparent it is best to mix it on a white surface such as a sheet of glass placed over white paper. The exact colour you want can be mixed at the edge of the glass and gradually merged into a pool of a turpentine-linseed oil mixture (or special glazing medium obtainable from some stockists) which occupies the centre of the glass.

whatever medium you're using, so if you are working indoors try to use a fair-sized palette, as it will take you a longer time before you have to clear spaces for new colours. In oils, it is worth keeping the mixtures you have cleared, as you may need them later on in a painting. I always scrape them up with a palette knife and place them in vacant positions at the edge of the palette. When I'm painting a landscape out of doors, instead of taking a large cumbersome palette, I usually ensure I have two smaller ones (which both fit into my box), so I can overflow onto the second one if necessary.

The quantity of paint to mix should always be more than you think you'll need. This applies particularly to watercolour washes, which really need a lot of paint. It is infuriating to run out of a mixture which has taken a long time to make. Try to keep your mixture clean. Each colour should be thoroughly mixed — unless you want it otherwise — and not allowed to run into its neighbours. In general, you should avoid mixing colours on the painting itself; although this technique can be used successfully, it often leads to muddying or an uncontrollable mess.

The tubes or pots of paint themselves must be looked after carefully. It is most important that their caps are screwed on immediately after use. If not, oil paints leak everywhere, acrylics, gouaches and watercolours harden in their tubes. Pastels should be replaced in their correct position in their box, otherwise you'll never find the one you want, especially if you are using a large number.

GLAZES AND WASHES

Mixing colours on the palette is not the only way to do it; they can also be laid over one another on the paint surface.

If a thin transparent wash is painted on a white ground, the colour it takes on depends on two factors. One is the amount of light that is reflected at its surface; the other is the amount of white ground showing through. A very thick wash will cover the white ground almost completely, so it will be more of its own colour. Glazing is a method of laying thin washes one over another so that each layer modifies the one below. Washes are most often asso-

Ian Sidaway paints in several different media, but he finds acrylic, which he has used here, particularly sympathetic to his careful, deliberate way of working. For this portrait he has used the glazing technique, which allows him to build up layers of colour without losing the luminosity of the child's skin. Very rich colours can be obtained in this way; the marvellous blues and reds seen in early Renaissance paintings owe their brilliance and depth to successive layers of very thin paint laid one over the other.

ciated with watercolour, but they can also be used in oil and acrylic painting as long as the paint is made transparent. To be successful, a wash or glaze must be more dilute than you might expect. Bear in mind that for the ground to show through, light must travel through the wash twice. It has to reach the white ground in the first place in order to reflect back through the paint. This reflected light gives a luminosity that cannot be achieved in any other way.

Watercolour
Because watercolour is transparent, paintings are always built up from light to dark, beginning with white

paper and laying successive skins of colour, called washes, one over the other until the correct colours and tones have been established. Washes can be used to change or modify a colour, or simply to darken it. For example, a sky which is too light can be given more strength by another wash of the same colour, while a red area which looks over-bright in relation to the rest of the painting can be toned down in places with a pale wash of another colour — perhaps blue or a darker red. Such washes must never be overdone — more than about three and the painting will begin to look tired and dead, as the white paper,

1 First I make a careful drawing with a sharp H pencil, working on a white-primed ground as this provides the back-illumination essential to successful glazing. Next I paint in the hair quite loosely with a thin mixture of cadmium yellow deep, yellow ochre, Payne's grey and white. Later on, the hair will be modified by glazes, but only when the entire picture surface has been covered.

2 As I am painting with transparent colour on a white ground, I find it helpful to mix on a white surface also, as otherwise I could not judge the colour values correctly. To block in the face I have made a thin mixture of cadmium yellow deep, cadmium red and white.

which gives watercolour its luminosity, will no longer show through. Also, the wetness of each wash tends to dissolve the first colour so that they mix rather than lying one on top of another. Each wash should be applied with a quick, broad brushstroke and not touched again. Normally, a wash must be darker than the layer it is covering, but an exception to this general rule is when a wash of a bright yellow (cadmium or lemon) is painted over any blue. The resulting green is actually greener and warmer than when a blue is placed over a yellow.

Acrylics

Acrylics are particularly well-suited to the wash technique, called glazing in this case, because they dry so quickly. Thus each layer can dry before the application of the

3 For the darker areas of the face I have used the same basic mixture, but darkened it by adding some cobalt blue. Notice how the paint at this stage, heavily diluted with water, behaves in rather the same way as watercolour, with blotches of accumulated pigment, bubbles and other marks occurring quite unpredictably.

next, and the original layer does not dissolve, giving a clear, true glaze. If acrylic paint is diluted too much with water, the acrylic medium will not hold the pigment to the surface satisfactorily. Very thin glazes are best applied by mixing the paint with a special acrylic thinning medium, available in both gloss and matt finishes. As with watercolour, the same general rule of dark over light applies, but again, blue over yellow or yellow over blue make equally successful greens, and a thin layer of white gives a smoky appearance to a darker colour. You can see how glazes overlap in Nick Andrew's picture of a Venetian market on page 23. Look especially at the ways the windows and floor are painted.

Oil

Glazing in oil is carried out in the

same way as in acrylics, but since oil paint takes longer to dry it is a much slower process — each layer must be fully dry before the next is applied. It is best to thin the paint with a glazing medium instead of an ordinary thinner like linseed oil, because oil does not hold the pigment in place so well. Nowadays special glazing mediums can be bought, which dry relatively quickly, and glazing is beginning to come back into fashion again. Formerly this technique was widespread: all the Renaissance painters made use of glazes, and Rembrandt created wonderful luminous effects by glazing over thick impastos.

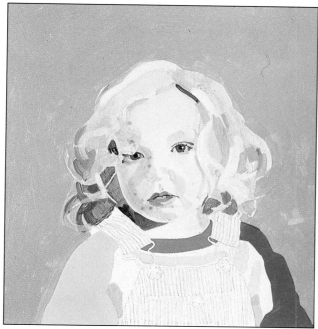

4 Now I begin to give some depth to the picture by modelling the hair, painting the dark parts with a mixture of Payne's grey, burnt sienna and yellow ochre. I have already painted the eyes, with cobalt blue mixed with Payne's grey and white, and the lips, for which I used burnt sienna and black laid over an earlier layer of cadmium red, naphthol crimson and cadmium yellow deep. Until this stage I had left the background white, which made all the other colours appear rather dark, so I quickly blocked in a mid-tone grey.

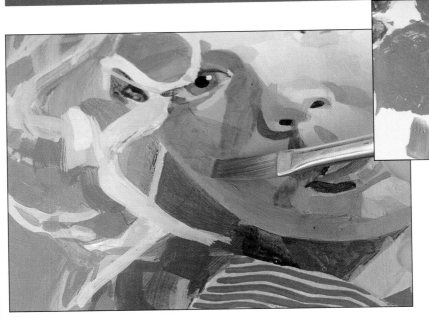

5,6 Now I am ready to begin on the glazing of the shadowed side of the face. I prepare a mixture of cadmium red and cobalt blue and thin it with acrylic glazing medium (I sometimes use water, but prefer the medium when painting skin as it gives a richer look). Once the glaze is mixed, I apply it with single broad sweeps of the brush. Working into thinned paint too much can cause it to form unpleasant bubbles and blotches.

7 Most of the glazing is on the face and hair, but I want to keep the same kind of treatment in all parts of the painting, so I create the shadows on the sleeve in the same way, applying a glaze of cadmium yellow deep, cadmium orange and a touch of raw umber.

8 This close-up photograph shows the cumulative effect of the numerous glazes laid one over the other on the face and hair. The transparent nature of the paint enables you to see through several layers in places, showing how the colours are progressively modified with each layer.

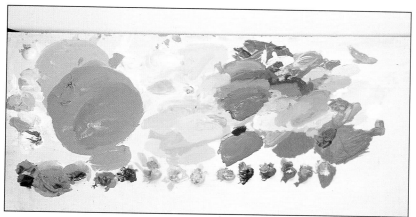

9 My palette for this picture is simply a piece of plastic-coated chipboard of the kind sold for shelving. I lay the paint out from warm to cool, which I find a help when mixing, and I have used the following thirteen colours: cadmium red, naphthol crimson, deep brilliant red, burnt sienna, raw umber, yellow oxide, cadmium yellow deep, cadmium yellow medium, cadmium orange, cobalt blue, cerulean blue, Mars black and Payne's grey. Notice that I did not use any green at all in this picture.

Portrait of the Artist's Daughter by Ian Sidaway, acrylic on white board, 12×10in/30.5×25.4cm.

USING BROKEN COLOUR

Another way of mixing colours on the painting surface is to place unmixed colours in numerous small patches side by side on the canvas. This is sometimes called optical mixing. If the patches of colour are small enough and at the same tone, they will appear to mix in the viewer's eye. Towards the end of the last century a number of painters, notably Georges Seurat and Paul Signac, carried this visual effect to an extreme, giving it the name of Pointillism, and creating pictures made up from an array of almost indistinguishable little dots of pure colour. It was a very slow process, and has not been done in quite this way since, but somewhat similar effects can be produced by using a spray gun or even flicking flecks of wet paint onto the surface using a stiff brush or toothbrush. This technique is called splatter and is most used by watercolourists, but it can also be done with oils or acrylics, using dilute paint.

Today, mixing colours by eye is quite commonplace. It is the way colour printing works. Look at the pictures in this book through a magnifying glass and you will see the tiny dots of red, yellow, blue and black which make up all the colours. Colour television uses the same system, but in red, green and blue only. In a painting, the patches of colour do not have to be dot-sized to come under the general heading of broken colour. Any patches of alternate colours that repeat themselves, however haphazardly, can be included. The pastel by Jo Skinner illustrated here obtains soft, gradual transitions of hue throughout the picture surface by the use of overlapping marks of pure colour.

Scumbling and dry brush

Scumbling is another method of mixing paint on the paper or canvas. It involves applying relatively dry paint to a painted surface which has already dried. Scumbles are usually applied in a circular motion, using a stiff brush or rag, and the paint is loosely pushed around in all directions, leaving little specks and patches of the underpainting showing. Any colour can be scumbled over any other colour, and the technique can give a rich effect of colour and texture. Very small amounts of scumbled colour can be effective in subtly modifying an existing one. Scumbling can be done in all the media, including pastel, although it is seldom called by this name in this case.

Dry brush is really a variation on scumbling, and although it can be used in all the painting media, it is most often associated with watercolour. It is a method of dragging paint lightly over an earlier layer, and is done by splaying out the hairs of the brush so that the paint is applied in a series of tiny lines. The paint must be mixed with the minimum of water or it will simply be a wash — a good deal of practice is needed to get the mixture exactly right.

Artist John Martin has made a lively and unusual still life from an arrangement of potted plants in front of a Victorian fireplace. The painting is in gouache, a medium he particularly likes, and he has chosen to work on a grey-toned paper, which gives the colour "key" to the whole picture. He describes in his own words which colours he used and how he modified and adjusted them by using the scumbling technique.

1 Having worked out a roughly symmetrical arrangement, I map out the outlines of the main shapes carefully but briefly in pencil. Since this is a small picture, which I intend to finish at one sitting, I do not include too much detail at this stage or the picture could lose the spontaneous, sketch-like quality.

2 I then establish the tonal relationships, using well-thinned paint. The "blacks" of the fireplace are a mixture of ultramarine and burnt umber, with a little alizarin crimson added for the more reddish tones. The surrounding yellow is composed of yellow ochre and vermilion, and the blue strip is cobalt blue diluted with white. (Vermilion is a very expensive paint, but I do find it a necessary extravagance on occasion.) The mauve-grey wall actually contains no black or grey paint, but is made of alizarin crimson, cobalt blue and white.

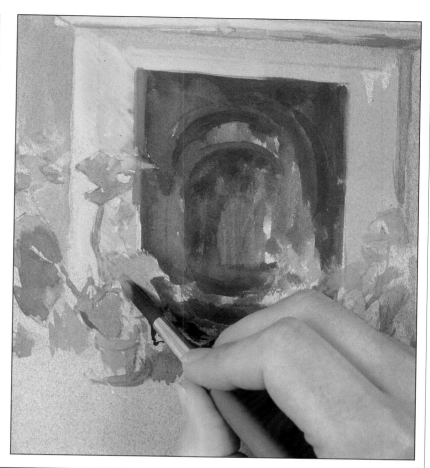

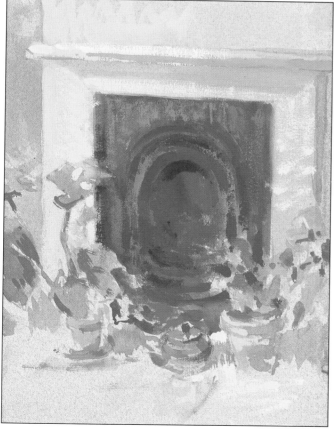

3 The next step is the leaves, for which I use a mixture of lemon yellow and cobalt blue. I try to cover as much of the picture surface as possible early on, so that I can judge the relationship of one colour to another before I begin the final adjustments.

4 Having painted in most of the colours I now begin to add more colour to the fireplace and surround by scumbling over the first layers of paint. The scumbled paint is used very dry so that it catches on only the highest ridges of the paper and leaves the underlying colour showing through unevenly. It is the perfect method for blending two or more colours without actually mixing them, and gives a much more interesting effect.

5,6 For the scumbling method to work really well, the colours must be mixed carefully so that they are slightly different in both tone and colour to the first layers of paint. If I had scumbled a very light colour on the fireplace it would not have kept to its proper place in the background. I arrive at the right colour by trying it out on a scrap of paper and holding this up to the painting. For the fireplace surround, I use cadmium yellow instead of the original yellow ochre, mixed as before with vermilion and white.

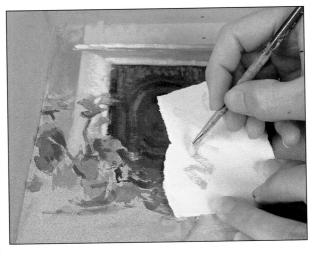

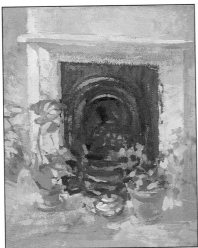

7 Before leaving the fireplace and turning my attention to the foreground, I add some final accents and highlights. This photograph shows how I have accentuated the curved relief shapes of the fireplace by adding streaks of cobalt blue mixed with white. At the same time I have given the teapot highlights of pure lemon yellow and blue-white mixtures. Notice how the curves of the teapot echo those of the fireplace, but in reverse, so that the middle area of the picture has a continuous flowing movement.

8 I have left the foreground till last because I wanted to adjust this up the focal point of the fireplace. In order to give the picture unity of colour and texture, I use the same scumbling technique here, applying a dry mixture of lemon yellow, alizarin crimson and white. The shadow of the pots is simply the blue-grey of the paper left bare. This is a technique often used in pastel painting, and the picture has a rather pastel-like look because I have used the paint dry and mixed the colour with a lot of white.

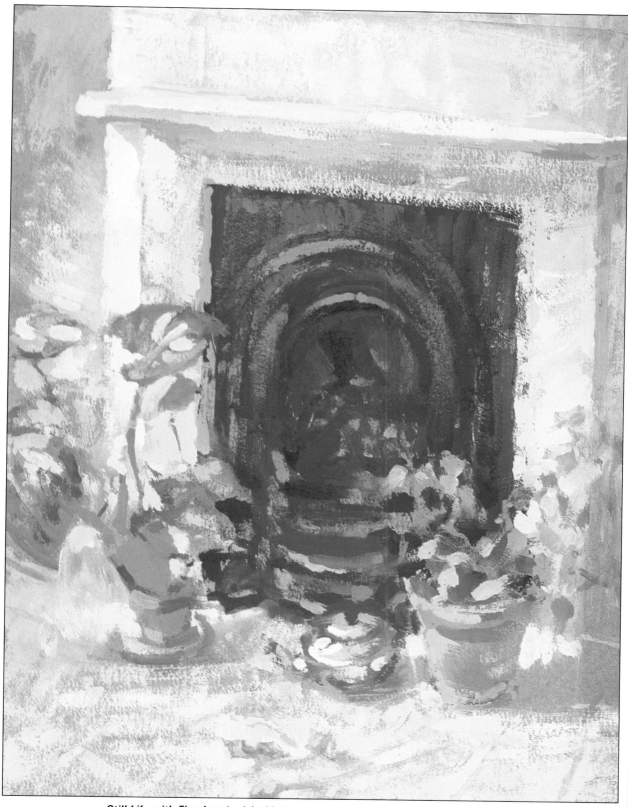

Still Life with Fireplace by *John Martin, gouache on grey paper, 5×4in/12.7×10.1cm.*

WORKING ON TONED SUPPORTS

Working on tinted surfaces is another variation of the wash or glaze techniques, only here it is the colour of the coloured priming that shows through the paint layers. Once a canvas has been primed it can be coloured uniformly using thinned paint applied with a rag or a large brush. Any colour can be used, but it must be chosen with the finished effect in mind. I often use a warm brown — raw sienna or a mixture of raw umber and yellow ochre — and sometimes I use a mixture of all or some of the colours left over on my palette after a day's work.

Painting can begin as soon as the ground is thoroughly dry to the touch. If you are using thin paint the colour of the ground shows through to some extent. A dark ground will lose the characteristic glow that occurs with a white one, which reflects back through the paint, but this is by no means a disadvantage unless the paint is very transparent, in which case it will not be very visible. When I'm out painting on location I always take with me a large selection of boards cut to different sizes and prepared in different colours. For warm subjects such as sunsets I often use blue boards so that the oranges and yellows are heightened by the little patches of blue showing through. The overall blue appearance given by the ground also helps to hold the picture together by establishing a colour key based on blue. It can be exciting also to paint over old pictures or on variegated grounds prepared speci-

John Martin nearly always paints on toned grounds, whether he is working in oil, as here, or in gouache. For pastel or gouache there is a wide range of coloured papers available, so it's just a matter of choosing one that relates to the painting, but for oils, the ground must be painted and allowed to dry before work can begin. Here the artist explains how he made his choice and how it has affected the finished picture.

1 Some artists like to paint on a colour that is the opposite of the "colour key" of the painting. For instance they may paint a snow scene on a warm-coloured ground so that the contrast makes the cool colours look even cooler. But I like to use a warm ground for a warm painting, and because I wanted this picture to give a real feeling of heat, I've kept all the colours warm, including the ground. I used a mixture of burnt umber and cadmium red, much thinned with white spirit and applied with a broad brush. I have done the underdrawing in blue paint rather than using pencil or charcoal, as it's basically a blue and mauve picture, and I wanted to keep the colours pure and bright from the start.

ally for this purpose. The different colours peep through the final picture, apparently at random, giving an interesting finish to the picture.

Thicker, drier paint will, of course, cover the ground more thoroughly, but if the paint is applied patchily, the ground will show through in those places which have been left bare. A warm ground is particularly useful if the painting is to be mainly in cool colours.

In paintings where thick paint is to cover the entire picture surface the colour of the ground is irrelevant to the final picture, but it is a help to the painter during the painting process. A pure white ground can be very dazzling and makes it difficult to judge colours, as it makes your paint seem much darker than it really is. Once the picture is finished you may be surprised to find your picture is pitched in a high tonal key, all your colours having been too light. A medium-toned ground prevents this from happening.

Pastel

Toned and coloured papers are a vital part of pastel techniques because of the limitations of mixing in this medium. Pastel papers are sold in a wide variety of colours, from bright greens and blues to very dark browns and black. Beginners in pastel would be well-advised to buy a pastel sketchbook containing several different colours and try them all out. Pastel paintings nearly always leave some of the paper exposed, because the pigment catches on the ridges of the textured paper but does not sink into the pits and troughs. Thus the colour and tone of the paper is very much part of the painting. A dark paper can be left exposed in places to stand for the darker tones in an otherwise bright picture, or the process can be reversed, with a bright-coloured or pale paper left to form the highlights. James McNeill Whistler often used a brown paper for his pastels of Venice, while the English artist Eric Kennington produced dramatic contrasts by working on black paper for his pastels of World War One.

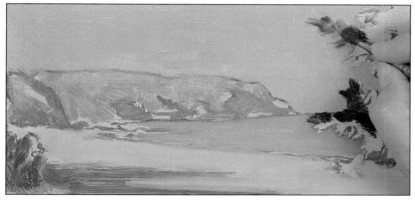

2 I begin by blocking in the big areas, using the approximate colours, which I will modify later on. The sky is a mixture of cobalt blue, white and a little alizarin crimson to give it extra warmth. Notice how the red-brown ground showing through already adds a sparkle, which is the effect I'm looking for. I have used red in all the colour mixtures; cadmium red and yellow ochre for the headland; the same red with lemon yellow for the beach, and viridian and a little alizarin crimson for the trees. The shadows are cobalt violet, balancing the hot blue of the sky.

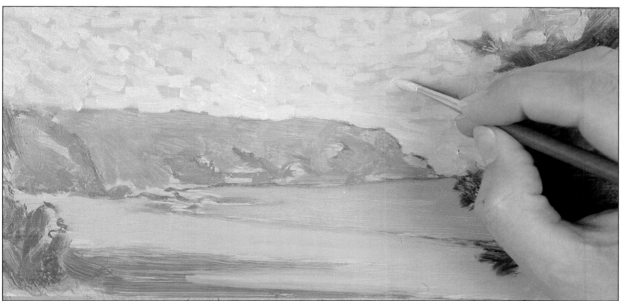

3 To break up the colour of the sky, I add patches of pinkish colours (cadmium red and alizarin crimson mixed with white) and then lay a cooler blue (cobalt blue and white) on top. Using broken colour instead of painting the sky as a flat area can often give a more realistic impression of light, but it is important to keep the tones very close to one another so that they blend together visually. Notice how the blue and pink patches are almost the same tone as the mauve-blue I started with.

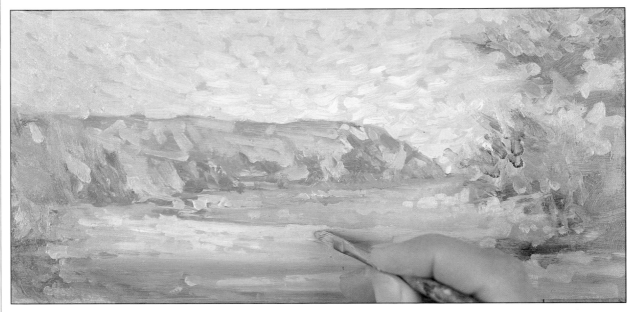

4 Once I was satisfied with the sky (though I knew I might have to make more modifications later), I began to work all over the picture, making adjustments in colour and tone. I added highlights of cadmium yellow and white to the trees and defined the headland more sharply with mixtures of yellow, red and cobalt violet. For the sea, I added an ultramarine and white mixture close to the cliffs, and lightened the inshore area with a greener blue made from cobalt blue and viridian mixed with white. I was careful to keep the tones very close to the original colour — too much tonal contrast here and it would no longer have looked flat. Finally I worked on the beach, lightening parts of it with yellow ochre and white with a tiny touch of red.

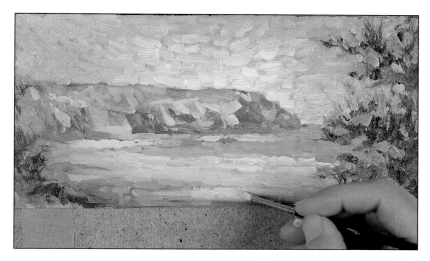

5 Now the painting was nearly finished, but I could see that a few final touches were needed. These included some more shadows among the foliage, in pure cobalt violet and an ultramarine and white mixture, a lightening of the shadow on the left, and a few small patches of lemon yellow and white in the sky over the headland. Darkening the trees increased the tonal contrast between them and the sea, so I added a little viridian to the sea in that area.

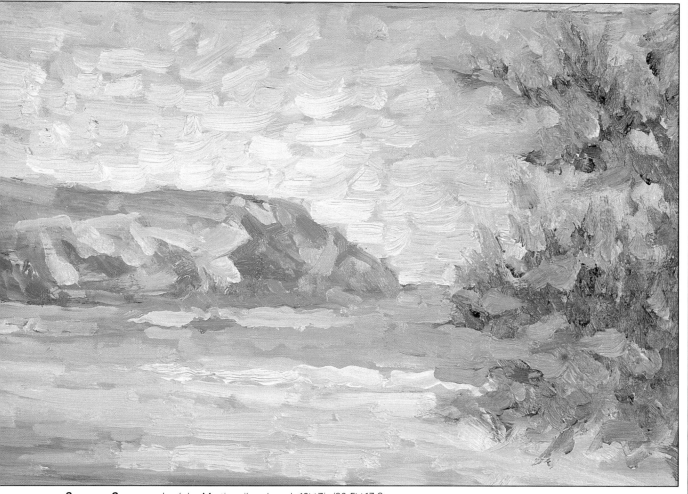

Summer Seascape by John Martin, oil on board, 12×7in/30.5×17.8cm.

WET-IN-WET

This technique is used in water-colour to obtain variegated washes where two or more colours "bleed" together. It is an exciting way of working because you never know quite what will happen. Watercolours used in this way are only partly controllable, but often the results suggest new ways of approaching a subject.

A wash is laid on the paper and while still wet another wash is laid in slightly thicker and darker paint. At the boundaries of the new wash the colour spreads into the first wash as fan-like streaks, intricate lace-like patterns — or sometimes unsightly blotches! Little actual mixing takes place, and as long as it is not touched again, the paint will not muddy. To some extent you can steer the direction in which the "bleeding" takes place by tilting the paper in the appropriate direction. The technique is much used by watercolourists to describe the soft contours found in cloudy skies.

A similar, though less dramatic technique is used in oils, and was much favoured by the Impressionists. They often scumbled or overlaid while the layer beneath was still wet, and sometimes deliberately tried to make colours run into one another. This can be particularly effective when creating soft effects in landscapes — skies, foliage or reflections in water. If touches of a lighter and brighter colour are applied over a still-wet darker one the two colours mix slightly, thus modifying one another. However, a light touch is needed, or a muddy mess may be the result.

Tom Robb likes to use the wet-in-wet technique for subjects like flowers and landscapes where he wants to create a soft, fluid effect, with no hard edges. Here he has used this same method all over the painting, but wet-in-wet can also be combined with wet-on-dry (washes laid over a previously dried layer) so that in some areas of a picture the colours mix together on the paper, while in others they are more precisely controlled.

1 The first step is to wet the paper evenly all over so that the paint spreads in soft shapes. I use a sponge for this, making sure that there are no very wet pools left before I begin to put on the paint. You can also use a large soft brush, but be careful to choose one that doesn't shed its hairs on the paper.

2 I begin with the lightest colours, using unmixed cadmium yellow with very little water for the bright yellow of the flowers. Notice that in this case I have done no underdrawing, as I want the finished picture to have a free, sketch-like quality.

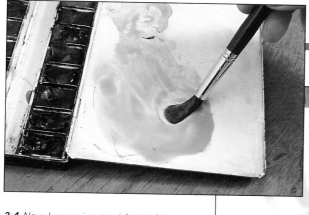

3,4 *Now I am going to pick out the stems of the flowers in green, so I return to the yellow still remaining on my palette and mix viridian green into it. This gives me a colour which is related to the original yellow, and very much the same tone. I like to keep all the colours close together at this stage, adding darker hues later to emphasize parts of the picture.*

5 *The paper is now beginning to dry slightly, so I can indicate the outside edge of the plate by laying in a broad, free wash of burnt umber in the foreground. If the paper had been too wet at this stage, the wash might have spread into the white area left for the plate — you never know quite what's going to happen with this technique.*

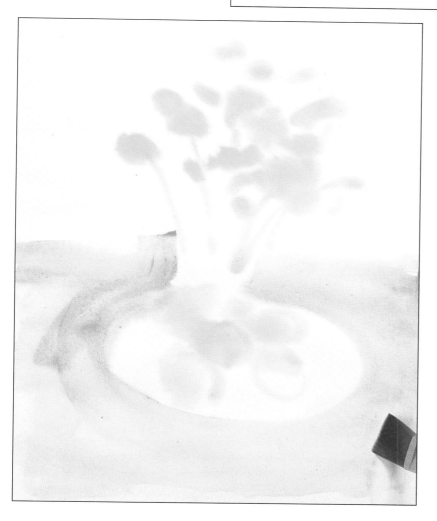

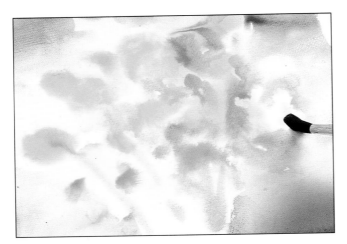

6 The flowers now need more variety and depth of colour, so I work into them with a strong wash made from yellow ochre and cadmium red to indicate the shapes, textures and shadows. At no stage do I attempt a precise description of the flowers, allowing the array of rich, softly blended colour to stand as its own statement. At this stage I also add some loose brushstrokes of Payne's grey and raw umber to the background so that I am no longer relating the colours to a stark white.

7,8 The final stage is to indicate the deepest shadows and tones to give the picture more depth and solidity. I pick out the dark green leaves with almost undiluted viridian, and for the shadows under the lemons and beneath the rim of the plate I use ultramarine and burnt umber both separately and in mixtures.

9 Notice that when working on the final details I have the paper at quite a steep angle because by now most of the paint is dry enough not to run down the surface. When working wet-in-wet it is often necessary to change the angle, sometimes laying the board down flat and sometimes tilting it away from you to make the paint spread in a particular way. The important thing to bear in mind is that this kind of painting is basically about using the accidents of washes to your advantage. You have to resist the temptation to make a conventional painting with lots of detail, and you have to work quickly with a "broad brush."

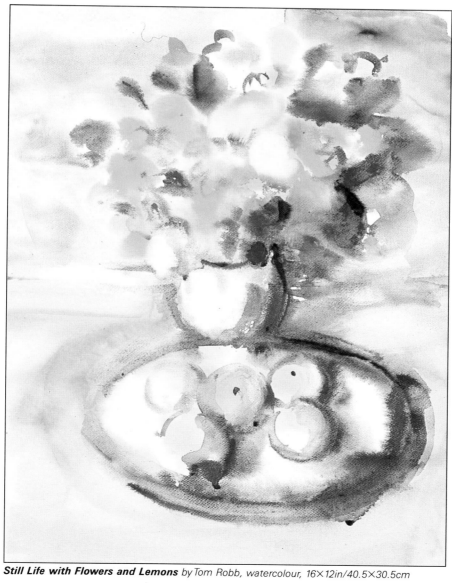

Still Life with Flowers and Lemons by Tom Robb, watercolour, 16×12in/40.5×30.5cm

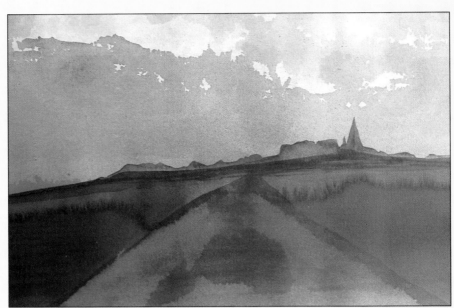

Rue de l'Église by Robert Tilling, watercolour, 16×22in/40.6×55.8cm.

PROBLEM SUBJECTS

You might think that, since all painting involves looking closely at a subject and recreating it on canvas or paper, the actual choice of subject matter should make little difference. But there is no doubt that some subjects are more difficult than others and place extra demands on the artist. There are several reasons for this, one being that people often just don't believe their eyes. The colours of foliage, for example, may be so far from what you expect them to be that you decide your eyes are wrong and your preconceived ideas right. Another problem is that some particularly bright colours, such as those seen in flowers, are unobtainable in paint, so you have to resort to visual "tricks of the trade" to obtain the right effect. Some subjects, such as metal, with all its bewildering reflections, have so many colours that you have to make a selection of the most important ones, while flat surfaces, such as skies or water, can cause endless trouble if you don't know how to deal with them. In this chapter we look at a selection of these difficult subjects, and I give some hints about how to overcome the problems.

TREES AND FOLIAGE

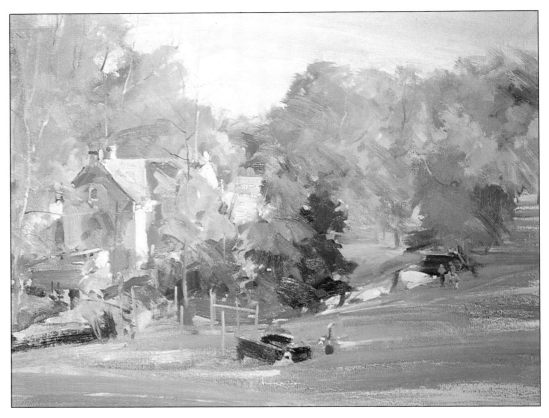

Autumn at Roche Abbey by David Curtis, oil, 18×22in/45.7×55.9cm. Pale yellowish greens give a fresh, spring-like atmosphere to this picture. The pinkish and blueish greys of the distant, still wintry, trees to the right contrast with the dark ones in the foreground, presumably evergreens, and altogether a wide range of colours is used for the "greens" of trees and grass. This gives a harmonious composition with a pleasing balance of warm and cool colours and light and dark tones, while the angular shapes of the house, treated in the same way as the foliage, help to unify the picture.

Possible colour mixtures: trees and foliage

Burnt umber

Phthalo green

Payne's grey

Yellow ochre

White

Winsor yellow

The questions that a painter may ask himself when confronted by foliage are: "How much detail is needed? Is it necessary to paint individual leaves?" "What is the minimum I can put on canvas and yet give the best impression of the foliage before me?"

In some respects our eyes are too good. They see too much detail, and often trick us into concentrating on the minutiae at the expense of larger shapes and patterns. This is fine for everyday life, and often an asset, but for the painter it is a potential handicap. Anyone intending to portray flowers or foliage has somehow to convert that mass of detail in front of him into a few marks of paint in such a way that the viewer of his picture can re-interpret them as the original trees, grass, flowers or whatever.

But how can you decide which features of the subject are the important ones? One way to do this is to blur your vision increasingly until the last moment that your subject is still recognizable. This can be done by almost shutting your eyes, by removing spectacles if you wear them, or by viewing the subject through frosted glass. In this way the subject will be reduced to the sim-

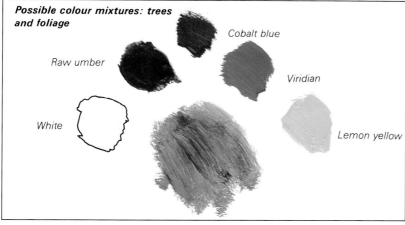

Possible colour mixtures: trees and foliage

Raw umber

Cobalt blue

White

Viridian

Lemon yellow

Suffolk Garden by Fred Dubery, oil, 12×10in/30.5×25.4cm. Just enough of the leaves of the blossoming tree have been painted to give the impression of a collection of individual leaves. The areas of sky visible through the distant poplars have been painted in afterwards rather than the trees being painted over the sky. This, of course, is only possible with opaque paints such as oil, but painting background over foreground in this way often gives a more convincing illusion. The tall foxgloves to the right are done in the kind of cool greens obtained by mixing lemon yellow with cerulean or cobalt blue.

plest of shapes, and these are the ones that should be painted in first. Individual leaves or twigs can be added later if you think it is necessary to describe the type of tree or plant, or if the painting still looks ambiguous and unfinished. Perhaps surprisingly, if you include too much detail, a painting will tend to become less true to life. Of course to a large extent it depends on how close you

are to the subject. The leaves on a distant tree cannot be seen clearly, while a potted plant right in front of you may well have leaves which you will want to paint individually, showing their shapes accurately as well. It is up to the painter to strike a suitable balance.

The colour of the paint marks must now be considered. There are difficulties here as well, because foliage

is all green. Or it it? It is true that if we were to pick a selection of leaves from one tree and examine their colour we would find they would all be identical or at least pretty similar. It is when they are on the tree, presented to us in every conceivable angle and position, that the variety of colours and tones is apparent, because the light strikes each one differently. The colours of individual

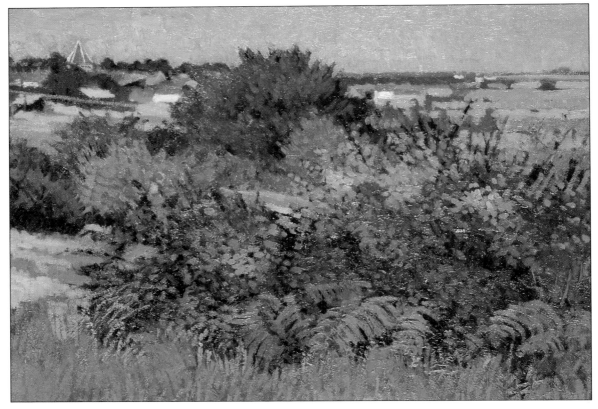

Fingring Hoe by Robert Buhler, oil, 25×30in/63.5×76.2cm. Most of the subject of this picture is foliage, and thus "green," but look at the range of greens used — pale yellowish ones, warm olives, cooler blue-greens. In the shaded parts, there are blue-greens and very dark browns. The shapes of the bushes are easily made out owing to careful drawing and skilful use of colour, but the sky and the distant village are vital in helping the viewer to establish the spatial relationships. Try covering these with your hand, and notice how the foliage on its own becomes rather meaningless and confusing.

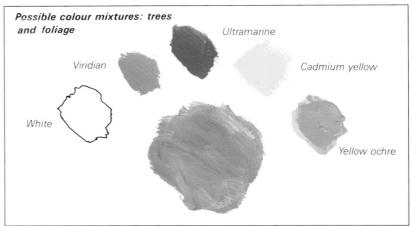

Possible colour mixtures: trees and foliage

Viridian

Ultramarine

Cadmium yellow

White

Yellow ochre

species vary widely too, and if we consider all the other types of vegetation the variety is extended further, even into the blues, yellows and reds. The painter must see these colours and know or find out how to mix their equivalents in paint. In Chapters 2 and 4, I explained which greens can be obtained by mixing from a limited palette, and also how some of the brighter ones can be obtained directly from tubes. Of the mixed greens, the warmer ones arise when you mix cadmium yellow with any of the blues, the richest and "greenest" being made from Prussian blue. Cerulean gives a clean, pale green, still warm, although with a hint of blue. Lamp black and Payne's grey also give warm greens; they are slightly brownish without being muddy. The greens obtained from a combination of lemon yellow with any blue, black or grey are all much cooler and bluer than a cadmium yellow mixture — it is the yellow rather than the choice of blue which governs the warmth or coolness of the green.

Foliage directly illuminated by the sun will probably need a warm green, whereas a shadow area will call for a cooler one. For a really

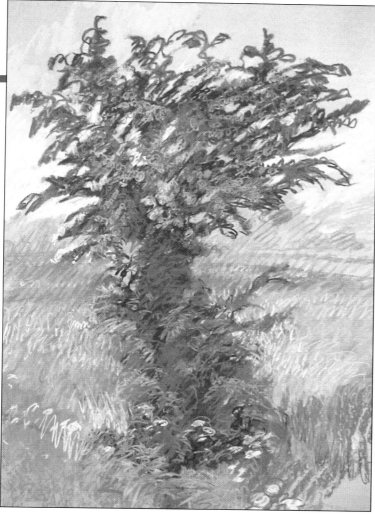

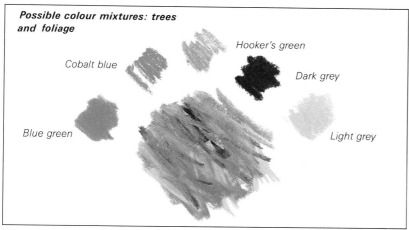

Possible colour mixtures: trees and foliage

Cobalt blue

Hooker's green

Dark grey

Blue green

Light grey

The Hawthorn Tree by Jo Skinner, pastel, 24×15in/60.9×38.1cm. Very rapid drawing, almost scribbling with the pastel sticks, helps to create the impression of the leaves and grasses flickering in the breeze. Notice the colours in the tree: the artist has used a foundation of dark green (perhaps a dark tint of Hooker's green), followed by ultramarine to emphasize the shadows, and lemon yellow running down the left-hand side. Patches of deep red give warmth and depth to the densest parts of the foliage.

bright, warm green I recommend cadmium green straight from the tube, but keep the areas small by adding tiny flecks or dabs to give an impression of sparkling, among darker greens. Emerald green is to be avoided for foliage since it is far too synthetic looking. Chrome green is a warm green similar to that obtained by mixing cadmium yellow and Prussian blue. Viridian and opaque oxide of chromium are both cool blueish greens. I use the former only occasionally, for the very bluest foliage, such as a field of cabbages, or for cool patches of shadow. Do be careful with these two greens — they can so easily pervade a picture if over-used, giving it an unnatural look. Viridian with cadmium yellow, on the other hand, mixes to a middle-temperature green rather similar to cerulean plus cadmium yellow, but mixed with lemon yellow it gives a strident colour similar to emerald green.

FLOWERS

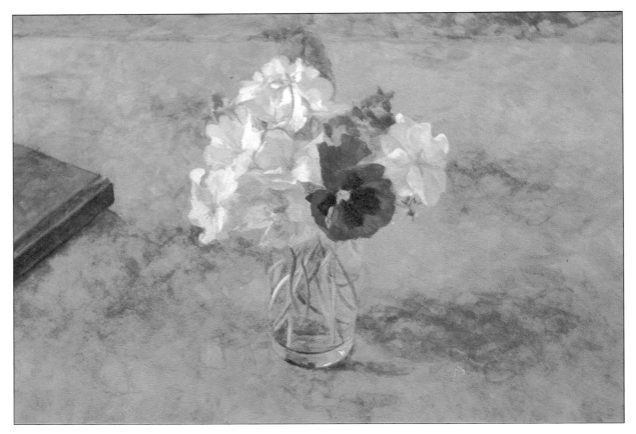

Posy with a Blue Pansy by Jacqueline Rizvi, oil, 8½×11½in/21.6×29.2cm. Very little, if any, pure white has been used here, most of the white petals having been painted in pinkish, yellowish and blueish greys. Some of these are actually lighter than the lightest parts of the blue pansy. The stalks in the glass have been beautifully observed, their shapes accurately drawn and their shadows and highlights carefully described, so that we are fully aware of the water in the glass even though it cannot be seen directly.

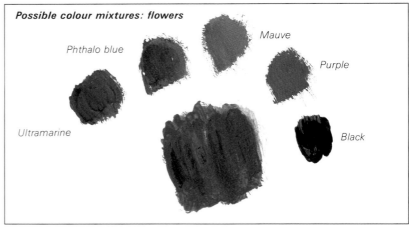

Possible colour mixtures: flowers

Phthalo blue

Mauve

Purple

Ultramarine

Black

The pigments that flowers produce are among the most brilliant colours found in nature, and some of these cannot be matched even by synthetic paints. Once you have started to paint flowers you will soon find that our starter palette is too limited and you will want to try some of the other colours available. Since the manufacturers' names for their paints vary somewhat (see page 140) it is best to ask in your art shop for the types of colour you want.

Sometimes you will be caught unawares during the course of a painting and will be forced to use the colours you already have. Fortunately there are various illusory devices available to the artist to make colours stand out and sometimes appear brighter than they really are. We saw in the previous chapter how the eye responds to colour relationships rather than absolute colour, so that it is quite possible to heighten the effect of a painted flower by contrasting it with its immediate surroundings. A neutral grey background will draw the

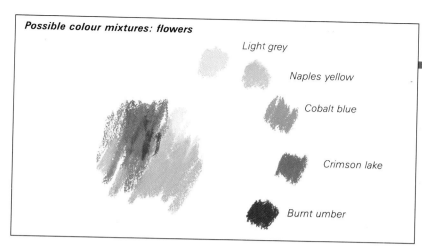

Possible colour mixtures: flowers

Light grey

Naples yellow

Cobalt blue

Crimson lake

Burnt umber

Chrysanthemums by Jo Skinner, pastel, 24×33in/60.9×83.8cm. Here the real flowers are integrated into the pattern of the background, unifying the picture as a colourful whole. The yellow flowers stand out, because they are contrasted with cool blues and violets, the latter being the complementary colour to yellow. All the colours look deceptively simple, but a close scrutiny reveals all kinds of unexpected tints and hues.

Sunflowers by John Ward, oil, 24×20in/ 61×50.8cm. The bright yellow of the flowers is highly illusory: if you look closely you can see that very little yellow has been used. Most of the petals are in warm greens, ochres and reds, and by reserving the pure colour for the highlights, the artist has not only given the flowers depth and form but made them appear brighter. The cool blue-grey background enhances this effect, forcing the flowers forward. Notice also how, although the tones of the table top and jug are very similar to those of the background, they are much warmer, and thus "read" as being on the same plane as the flowers.

Possible colour mixtures: flowers

Raw sienna

Yellow ochre

Burnt umber

Cadmium yellow

Emerald green

viewer's attention to the colours of the flowers, and if the background is dark, the apparent tone of the flowers will be raised, the contrast making them seem brighter than if the background were light. The cooler colours — the blues, greys and blue-greens — tend to recede when contrasted with warmer ones, like red, orange and yellow, so if a red flower is placed in surroundings of a cool colour, the flower will make its presence felt by dominating that area of the picture. When complementary colours are placed side by side they set up a dazzling effect where they meet, and the warmer or paler one of the pair will appear much more brilliant.

Try to keep the colours fresh by not over-mixing, particularly in water-colour. To achieve greater luminosity for painting delicate petals in water-colour, the more transparent the paint the better, as the white paper can reflect through it. Instead of using the more opaque cadmium colours, those such as permanent yellow, permanent red or vermilion may be a better choice (though ver-

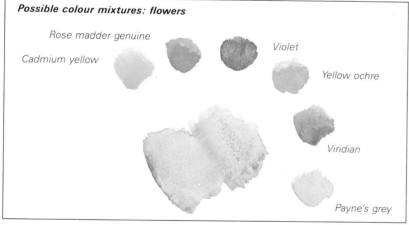

Rose madder genuine

Cadmium yellow

Violet

Yellow ochre

Viridian

Payne's grey

Winter Rose in a Lalique Vase by David Hutter, watercolour, 12×10in/ 30.4×25.4cm. The vibrant pinks and yellow-greens in this lovely, delicate painting owe much of their richness to the colour of the background, which has been chosen with great care. A neutral but far from characterless grey-brown, it is dark enough to make the flowers and leaves stand out but not so dark they look like paper cut-outs. The flowers themselves are carefully modelled, and the rose shows a considerable range of both tones and colours, from the pale pink highlights at the edges of the petals to the dark blue-red of the shadows.

milion is very expensive). In water-colour, ultramarine and cerulean are less transparent than cobalt or phthalo blue. Cerulean is quite surprisingly opaque, and needs to be handled with some caution. Some of these effects can be found in the accompanying illustrations. Have a look also at the pastel by Frances Treanor on page 69.

So far I have discussed making paint appear brighter than it really is, but sometimes flowers are actually less colourful than they seem — it is more a case of what we expect than what we really see. Take the picture of daffodils for example (see page 56). We all know that daffodils are yellow, but when we set about painting them it comes as a surprise to find that very little yellow paint is needed. A major proportion of the petals turns out to be shades of green and ochre, but a casual glance at the picture still shows us the daffodils as yellow.

SKIES

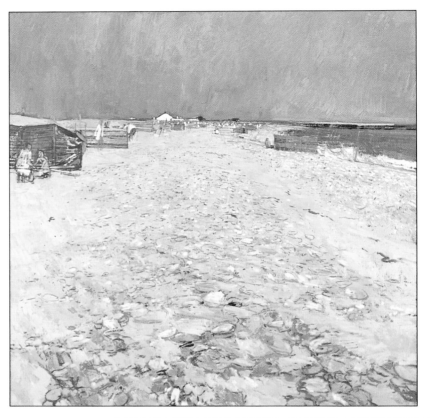

Walberswick *by William Bowyer, oil, 36×36in/91.4×91.4cm. The cloudless sky has been treated very freely, with each brushstroke discernible. The sky has been made to look much richer and more blue by adding touches of other colours, such as mauves and pinks, and it has been treated in the same way as the rest of the painting so that it forms an integral part of the composition. The picture is further unified by the way colours have been repeated. The blue of the sky is echoed in the windbreak, appearing again in more muted form in the shadowed sides of the foreground pebbles.*

Possible colour mixtures: skies

Cobalt blue

Phthalo blue

Ultramarine

White

Alizarin crimson

Sky may occupy up to three quarters of a landscape painting, so it naturally plays an important part in the composition as a whole. A painting, by its very nature, is a series of brush marks on a flat surface, but at the same time the paint also gives the illusion of the subject which the painter is intending to depict. The difficulty with skies is the successful creation of this "double identity" of the paint; so often it just looks like paint, failing miserably to appear like sky as well. Clouds are notoriously difficult. How can paint give a convincing impression of such distant, soft, amorphous forms?

Flat areas of uniform sky

In some respects the more variety there is in a sky the easier it is to paint because your brushstrokes will have more obvious meanings. Sometimes the sky does appear totally uniform, particularly when hazy or completely overcast, but even if it has consistent colour value throughout — usually close to white — if you paint it as you would a wall the result will in most cases disappoint you. Paint will always look like paint however smooth a surface you

Cley Mill by Jeremy Galton, oil, 12×18in/ 30.5×45.7cm. This part of the thinly overcast sky, away from the sun, is relatively dark, forming a natural backdrop for the white sails of the windmill. The sky was painted in just one colour, a mixture made from white, a little Payne's grey, raw sienna and ultramarine, and the paint was applied thinned with turpentine to allow some of the warm ground colour to show through. A very limited palette was used for the picture, and it was completed on the spot in one session.

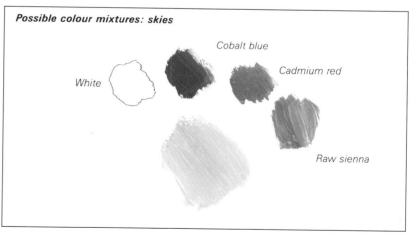

Possible colour mixtures: skies

White Cobalt blue Cadmium red Raw sienna

give it. To make it look like the sky as well we can make use of various tricks of deception. The handling of the paint must be the same for the sky as it is for the rest of the picture so that the eye links the two areas as a whole. The brushstrokes should be compatible in size throughout the picture, with those of the sky echoing those of the land or sea. When painting with opaque paint on a dark-toned ground, it helps to allow this to show through in patches, easiest to achieve if the whole painting is begun in thin paint. With pastel, the ground usually sparkles through in any case. Breaking up the painted surface in this way rather surprisingly enhances the illusion of sky, even while emphasizing the fact that it is really paint.

The other main task is somehow to make the paint appear as though it is far in the distance, just as real sky is. A trick I frequently use to make the sky recede is to break up the paint surface by adding small dabs of paint of identical tone but of different colour. For instance I may have painted a sky in a thin creamy white colour. By adding small patches of a blueish paint of the same tone the

103

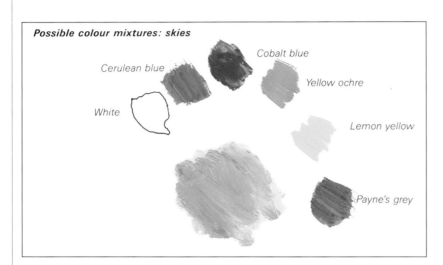

Possible colour mixtures: skies

Cerulean blue

Cobalt blue

White

Yellow ochre

Lemon yellow

Payne's grey

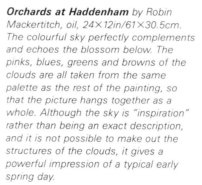

Orchards at Haddenham by Robin Mackertitch, oil, 24×12in/61×30.5cm. The colourful sky perfectly complements and echoes the blossom below. The pinks, blues, greens and browns of the clouds are all taken from the same palette as the rest of the painting, so that the picture hangs together as a whole. Although the sky is "inspiration" rather than being an exact description, and it is not possible to make out the structures of the clouds, it gives a powerful impression of a typical early spring day.

sky will now take on a glow, which may be difficult to focus on, and thus appear to the viewer as sky. The use of patches of complementary colours stippled throughout the sky can sometimes have the same effect. Our eyes cannot focus perfectly on more than one colour of light at once so that, coupled with the dazzling properties of complementaries placed side by side, the sky becomes intangible and recedes into the distance.

In watercolour, skies are usually painted in thin washes of dilute colour, surface variation occurring automatically because it is virtually impossible to lay a totally flat wash. Accidental effects can often be used to advantage, and it is wise to make the most of the unpredictability of the medium.

Cloudless skies

You may be deceived into thinking that a perfectly blue sky is also uniform, but there is usually a marked gradation of colour and tone downwards to the horizon. Again our expectation is more powerful than our observation, but next time you are in front of a large expanse of sky try turning your head so as to view the scene upside down. At once you

will notice colours you never expected to be there and you will be surprised at the difference between the horizon and the higher elevations. A clear, dark blue sky pales towards the horizon, sometimes becoming yellowish or pinkish, the exact colour depending on the amount of water vapour and haze in the air.

In a simple oil painting I usually find it sufficient to mix up the colours of three areas of sky — towards the top of the picture, half way down and close to the horizon. The junctions between these areas must be handled carefully. Obviously a boundary

Robin Machin

must not be sharp, but if the colours are mixed on the canvas the paint begins to look like paint rather than sky. What I do is to allow horizontal brush strokes of one colour to encroach into the adjoining area, and vice versa. This makes the boundary difficult to see, but keeps a suitably broken paint surface.

As we saw in Chapter 3, a blue sky is often less blue than we think, necessitating considerable dulling of blue paint from the tube. In oil, cerulean is often a useful paint here, as only tiny amounts of other colours are sufficient to dull it to the required colour and tone. It is less useful in watercolour, and can really only be used pure, as it does not mix well. Close to the horizon the amount of blue paint required is often minimal, whites, ochres and crimsons sometimes being all that is necessary.

How light is the sky?
A landscape receives all its light from the sky, so the sky must be, on average, lighter than the land it illuminates. I say on average because the sky is seldom a uniform brightness, least of all when it is clear and blue and most of the light comes directly from the sun. Away from the sun the sky is quite dark. When compared with the lighter features in a landscape including buildings, a blue sky can be seen to be very dark. The more haze there is the lighter it becomes. An overcast sky is usually of a fairly uniform brightness, owing to scattering of light by cloud, and sometimes it is so bright that it is impossible to paint the true tonal contrast between the sky and the land. On these occasions remember that, above all, you are painting a picture rather than simply copying your subject, and a darkening of the sky can be quite permissible. Sometimes a cloudy sky is very dark in one area, but the landscape below it is

Storm Over Rutland *by Ray Ellis, watercolour, 11½×25in/29.2×63.5cm. Successive washes, wet on dry, have been used for the sky, followed by some scumbling with a stiff brush and dryish paint to modify and soften the contours of the clouds. The streaks of rain have also been scumbled, both light over dark and dark over light. There are very few warm colours in this picture, which is why it gives such a powerful impression of a cold, blustery, showery day. As is always the case, the clouds are larger at the top of the picture, becoming smaller and smaller as they recede into the distance at the horizon.*

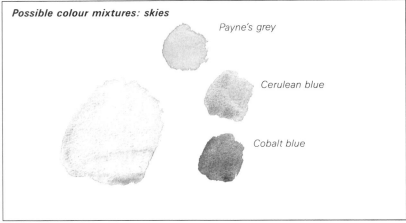

Possible colour mixtures: skies

Payne's grey

Cerulean blue

Cobalt blue

still being lit by the sun and is consequently very pale. In such a case, if we turn round we will see a bright sky and sunshine, with the landscape below it darker than the sky.

Painting clouds

Look carefully at the colours of clouds. They are often totally unexpected both in colour and in tonal range. The colour of a cloud depends firstly on its illumination. When the sun is low as at the end of a day or in winter its light is yellowish, and the side of a cloud lit by it will be a light yellow. The other side of the cloud, in shadow, may be reflecting blue sky, so will appear a dark blue-grey, but sometimes it may be brownish, particularly when overhead. If there are a lot of bright yellowish clouds in the sky you may find that the shaded sides of the clouds appear violet — the complementary of yellow. The higher the sun in the sky the less varied are the colours of the clouds, the lightest parts appearing very white indeed. Secondly, the colour of a cloud can be modified by its distance — the more atmosphere (containing even the thinnest haze) there is between the cloud and yourself, the more it tends to yellow, pink or

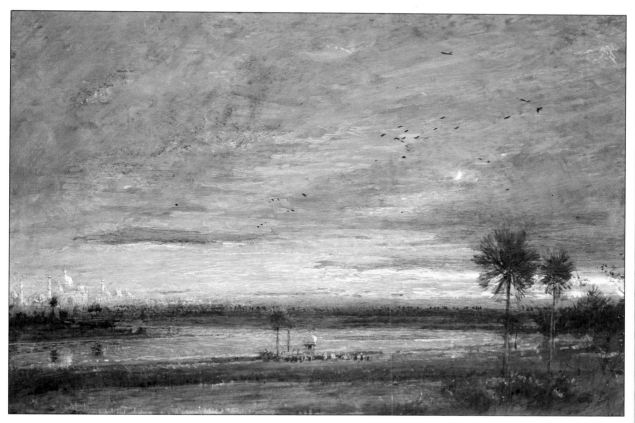

Possible colour mixtures: skies

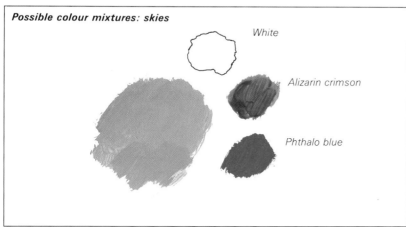

White

Alizarin crimson

Phthalo blue

The Indian Winter, Taj Mahal by Albert Goodwin, oil, 10×14⅝in/25.4×37.5cm. The richest and most varied colours occur at sunset, and artists have always been tempted by them. Here there are several layers of cloud, each reflecting different colours, and each with its own aerial perspective, apearing to bunch together as they approach the horizon. The artist has used a wide range of blues, from deep ultramarine at the top to cerulean at the bottom lightly scumbled over with pale yellows and pinks.

violet. Chaotic cloudy sky has the greatest variation in colour. It is an exercise in mixing greys — brownish greys, bluish greys, pinkish greys, yellow greys and so on. At sunset all the colours of the spectrum appear, giving you the chance of painting with brilliant reds and yellows close to the sun, and blues and greens away from it. You'll have to be quick though — the sky changes by the minute.

Remember that the shapes of clouds are important. They are not merely amorphous random masses, but have a definite structure, albeit a constantly changing one. On any one day they will form at a particular level (sometimes two or three levels simultaneously under certain conditions), and they thus form a kind of ceiling which follows the normal rules of perspective as it vanishes into the distance. They appear to be far more bunched together towards the horizon, and their apparent size increases to a maximum overhead. The blue sky between scattered clouds will appear more extensive overhead than in the distance, simply because we cannot see through these spaces at too much of an angle.

SNOW

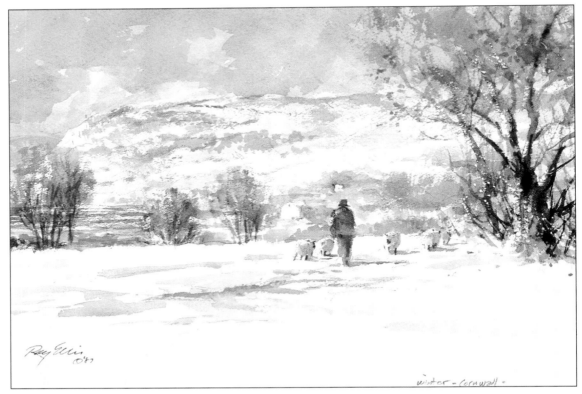

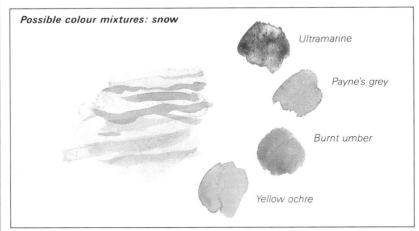

Possible colour mixtures: snow

Ultramarine

Payne's grey

Burnt umber

Yellow ochre

Winter, Cornwall by Ray Ellis, watercolour, 9½×14½in/24.1×36.8cm. Here a combination of small areas of wet washes and dry-brush work creates a lively, sparkling scene in spite of the predominantly blue-grey colour key. On a cloudy but bright day such as this (the sun is evidently only lightly covered by cloud) a wide range of colours is present, and the artist has observed and recorded them carefully. Notice the greenish hue of the sheep, the pink-brown of the trees in the central background and the ochres and greens of those at the left. A scalpel has been used to scrape away tiny areas of paint on the branches of the right-hand tree, suggesting a dusting of snow.

Fresh snow, the tops of cumulus clouds lit by the sun and breakers at the seaside are among the whitest features to be found in nature. But even though their local colour is pure or almost pure white, the colours we perceive stray dramatically from this, depending on the lighting conditions, reflections from adjacent objects and our own viewpoint.

In winter the sun is always low, and if the sun is shining from a clear blue sky, the areas of the snow being illuminated directly will appear dazzling white. If the snow is lying on undulating ground it will vary in colour and tone depending on the exact angle in relation to both the viewer and the sun. Areas largely turned away from the sun will be mainly reflecting light from the blue parts of the sky, so will appear blueish, and there may be shadows (long because the sun is low) which for the same reason will also be blue or blue-grey.

On a cloudy day the colour of the snow will depend on the thickness of the cloud cover. When the winter sun filters through thick cloud it is often quite yellow, and the snow often will reflect this colour. There will, of course, be no clear-cut shadows, but shaded areas, hidden from the yellowish light, will take on something of the complementary

St Jude's in the Snow by Jeremy Galton, oil, 7×10in/17.8×25.4cm. This painting was done on a warm ground of yellow ochre mixed with raw umber, which emphasizes the cool snow colour by contrast. The whiter parts of the snow, such as the foreground, are pure titanium white straight from the tube, its starkness tempered by the dark ground showing through over much of the area. The very whitest patches are painted in very thick white paint. The shaded area beyond this foreground is white mixed with ultramarine and raw umber, while the brighter blue patches to the left and right of this darker band is cerulean blue with small amounts of white and raw umber added. This picture was painted on a bitterly cold afternoon and took exactly two hours from start to finish.

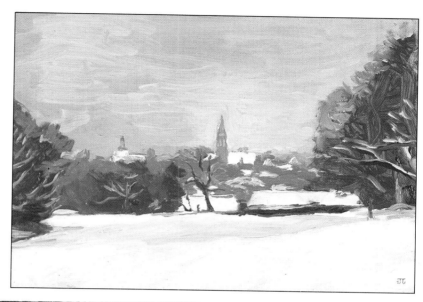

Winter's Light by Cathy Johnson, watercolour, 15×22in/38.1×55.9cm. A large area of the white paper has been left exposed in the foreground, with the blue shadows laid in lightly and softly with no hard edges so that they suggest the gentle undulations of the snow-covered ground. The artist has used the red-gold of the central tree as a foil to the blue and mauves in the background, and the wintry effect is heightened by the delicate, rather calligraphic drawing of the tree-trunks and branches. The shining white snow is thrown into relief by the small areas of near-black at the base of the trees and on the wall of the pavilion.

hue of violet, together with various cool greys and purples.

In oil paint all these variations of "white" can be mixed by starting with pure white from the tube and adding bit by bit the blues, violets, reds and ochres and so on until you have the desired colour. As snow is cold and the shadows are cool blues and greys, it is often helpful to emphasize the coolness by painting on top of a warm ground of ochre, raw sienna or even a red. The ground will show through the thinner patches of cool paint, also helping to break up monotonous white areas into a more exciting pattern and aiding the illusion of snow by baffling the eye. A little confusion helps us to forget that we are merely looking at paint on a flat surface — our eye is compelled to sort out what the artist intended.

In watercolour, bare white paper is the equivalent of white oil paint straight from the tube. Thin pale washes can be used to break up parts of this surface, and progressively darker colours can be added, ending with the darkest shadows. As always, nothing can beat looking, seeing and experimenting.

METAL AND GLASS

Possible colour mixtures: copper

White

Lemon yellow

Yellow ochre

Emerald green

Cerulean blue

Cadmium red

Redcurrants in a Copper Pot with a Rose by Pamela Kay, oil, 12×14in/ 30.5×35.6cm. *Copper has more "local" colour than the white metals, and although it reflects in the same way, all the reflections are suffused with pink. As can be seen here, the pinks and reds are most completely reflected. The impression of the glass is created by just a few accurately placed highlights, while the redcurrants have tiny highlights on their convex surfaces, diminishing in size and brightness as they recede into the back of the picture. They gain their translucent appearance from the fact that they have no dark and light side, most of the light falling on them being reflected from within the body of each fruit.*

These are best treated together because in a sense they are opposites, but with similarities. Metal reflects all the light falling on it whereas glass lets most of it through. The appearance of a metal object depends almost entirely on its surroundings, which it will reflect in a multitude of distorted shapes. These shapes are dictated by that of the metal object itself, which calls for very careful observation when setting out to paint. The paint mixtures to use for the reflections will be very similar to those used for the surroundings, but bear in mind that the reflections are often a little less brilliant in colour than the originals. This is not always the case, though. Convex metal surfaces concentrate reflections into small areas, giving high-intensity patches of colour we call highlights, and if these happen to be reflections of the sky or a strong light source they are particularly bright. The inclusion of these in a painting will increase the illusion of shininess.

Similarly the darker areas of the surroundings will be concentrated by convex metallic surfaces so that the general appearance of a shiny metallic object is that of extreme light tones side by side with extreme dark ones. Often these reflections form such intricate patterns that

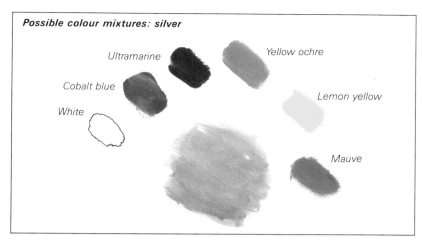

Possible colour mixtures: silver

Ultramarine

Cobalt blue

White

Yellow ochre

Lemon yellow

Mauve

Teapot by John Martin, gouache, 9×6½in/23×16.5cm. Metals have little "local" (their own) colour, but they do have some. Although a metallic object is largely a composite of the reflections of its surroundings, a silver teapot, like the one here, will call for a different mixture of colours to that used for a gold or brass object. In this gouache painting, the artist has used blues, mauves and greys for the teapot, which reflects some of the pale blue from the stripes on the mug. Notice how the shapes of the highlights and reflections describe the different surfaces of the objects themselves. Very careful observation is needed when painting reflective surfaces.

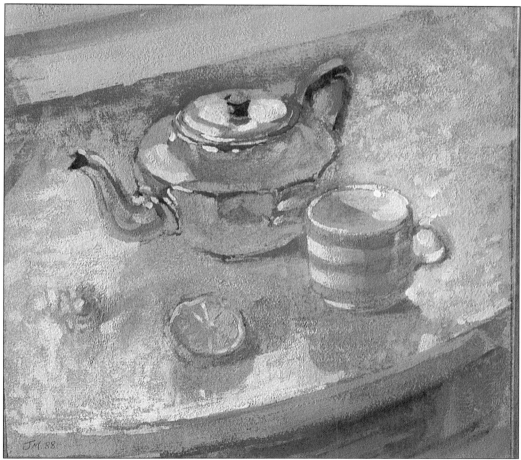

they cannot all be painted. Instead try to simplify the shapes. If you have difficulty doing this try half closing your eyes so that you see only the most important ones.

Apart from the shiniest metallic objects, many metals appear predominantly of different shades of grey. This is because their surfaces are often covered with myriads of tiny scratches through wear which, together with tarnish, scatter light to

some extent, giving less true reflections. Brilliant colours will be reflected more dimly, so that you will have to dilute the paint more for the reflections than for the original sources of them. Aluminium always has a thin coating of oxide on its surface which scatters the light so that the highlights are muted and the darker areas lightened a little. A quick way to mix these colours is to start with lemon yellow (or Naples

yellow if you have it) and a little ultramarine (to give a greenish grey) followed by a little red (to counteract the greenness). Different reds in different amounts will give a range of greys, many of which may suit your requirements. Metals (apart from copper and gold) tend to look cold. This is partly because we know them to feel cold to the touch but partly because the tarnish or scratches do actually reflect the

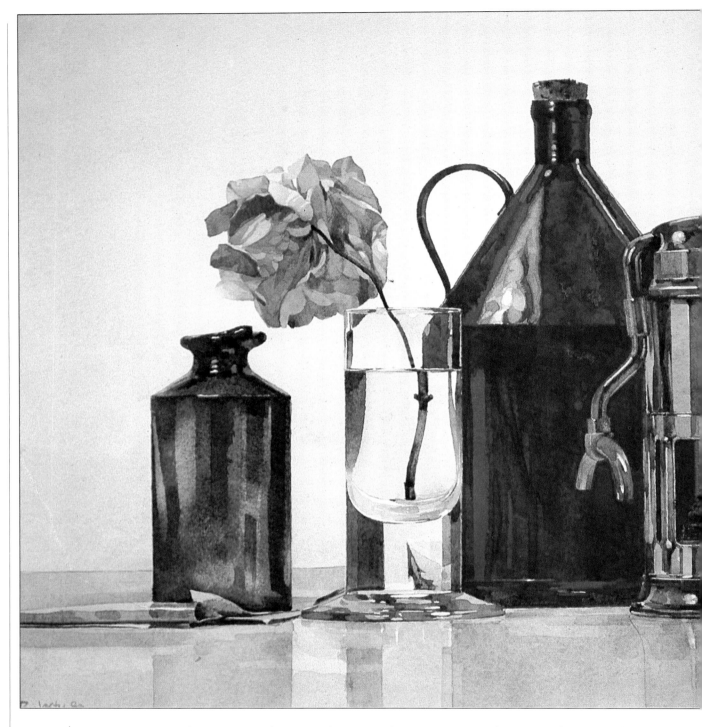

cooler colours (the blue end of the spectrum) more efficiently than the warmer ones (the red end of the spectrum). To mix the colours of copper and gold and their alloys, which are pink and yellow respectively, it might be a good idea to start with an alizarin crimson and white mixture for copper, and ochre for gold. Modify these colours according to the reflections seen in these metals. Copper and gold look

warm because these metals are best at reflecting the warmer end of the spectrum.

As light travels through curved glass it bends, giving rise to the characteristic distortions of the objects seen through it. Glass also reflects light, particularly when it is viewed at a low slanting angle to its surface. Thus a jam jar will reflect light at its edges, and it is also here that distortion is at its greatest. Tonal contrasts

can be quite large at the edges, the highlights sometimes approaching pure white, and the dark areas being as dark as other dark tones in the surroundings. The least distortion and reflection occur at the centre — here what we see is not so much the jam jar as the absence of the jam jar.

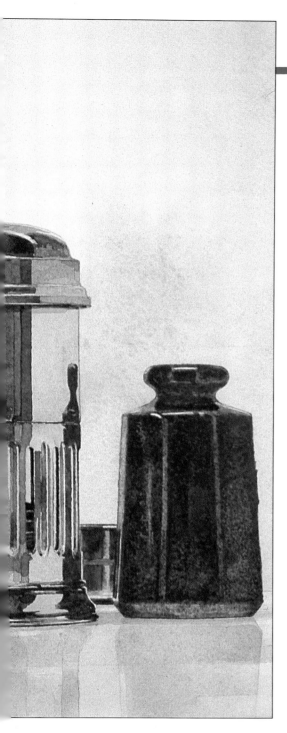

Still Life with Hydrangea by Ronald
Jesty, watercolour, 13×18in/33×45.7cm.
The shiny glaze of the dark blue
container reflects its surroundings, but it
is only the very brightest area of
reflected light that hides the blue. Glass,
unlike metal, transmits most of the light
striking it. Light is bent as it travels
through curved glass, and the images of
objects seen through it are always
distorted. Here the stalk of the flower is
magnified and shifted in position, and
because of the curve of the glass, none
of the blue container can be seen
through it.

Possible colour mixtures: glass

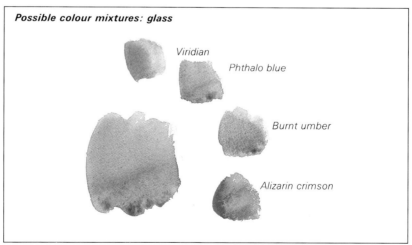

Viridian

Phthalo blue

Burnt umber

Alizarin crimson

WATER

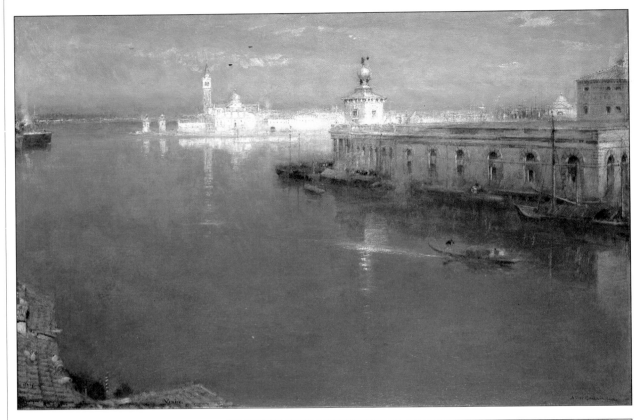

San Giorgio and the Dogana by Albert Goodwin, oil, 23×35in/58.4×88.9cm. Calm water is a particularly tricky subject. Paint it too flat and it looks solid and static, but too much variation in tone and colour will ruin the impression of a horizontal, liquid surface. The artist has made the water much darker in the foreground (as it always is), while the farthest stretch is a bright blue reflected from the sky. But he has kept the transition from dark to light very gradual, and each area of colour is composed of several different hues of the same tone so that one has an impression of the movement and transparency of the water.

Possible colour mixtures: water

Cobalt blue

Phthalo blue

White

Ultramarine

Winsor green

Clear, clean water, like glass, allows us to see through it to whatever is at the other side, usually the mud, sand or rock below it. If the water contains suspended mud or vegetation then the water takes on its own colour — for instance, mountain streams are often brownish because the water is coloured by peat, while the sea in some places is greeny-brown from the algae in it. Water also reflects light at its surface, and thus acts as a mirror. For painting purposes these are the three important points to remember. It is the reflections that usually play the most important part in contributing to the appearance of water in a landscape or seascape. Unlike a mirror the strength of reflec- tion increases in proportion to the degree of slant with which you view the water. A calm lake in the dis- tance reflects almost a hundred per cent of the sky: if the sky is blue, the lake is blue; if the sky is grey the lake is grey. In contrast, if you look down from a bridge into a slow-flowing river, most of what you see is the river bottom or mud suspended in

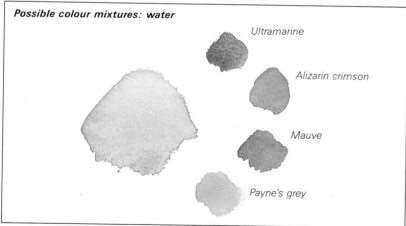

Possible colour mixtures: water

Ultramarine

Alizarin crimson

Mauve

Payne's grey

Still Evening by Trevor Chamberlain, watercolour, 7×10in/17.8×25.4cm. Broad washes of watercolour have been used, with the minimum of colour variation. In some places the paint has been used wet-in-wet, causing the colours to mix by "bleeding" into one another. This can be seen in the clouds, and in the water just behind the distant boat. In the foreground, washes have been laid over dry paint, leaving small, clearly defined lines of lighter colour, suggesting the light catching on a gentle swell. Because the water is so calm, it is almost the same colour as the sky, but it is not a flat area of tone: notice how it gets much darker towards the foreground.

the water, with possibly a weak reflection of yourself and the sky above. Thus any stretch of smooth water becomes lighter with distance as it reflects more sky. Nearby areas of water may be reflecting buildings or trees, but the same principle applies.

The reasons why choppy water is so difficult to observe, and therefore to paint, are threefold. The first thing you have to take into account is the shapes of the waves or ripples; the second is their colour; and the third is the fact that the water simply will not keep still. Look carefully to see what is being reflected — this is always vertically above the reflection. The colour of the reflection is always a little duller than the original, so add a little raw umber or Payne's grey. Each wave or ripple will be reflecting more than one colour, but don't try to be too precise; these are usually adequately represented in paint by interspersing horizontal patches of colour.

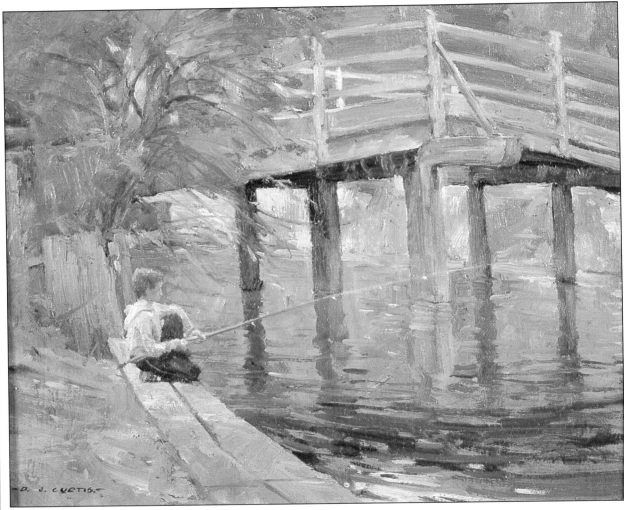

Fishing at Flatford Mill by David Curtis, oil, 10×12in/25.4×30.5cm. It is not always easy to make the ripples in water look natural. The secret is to observe them carefully. The ripples themselves are not really visible — what we see are distorted reflections and, from a close viewpoint, some of the dark water beneath the surface. Each ripple has convex and concave surfaces, which reflect features directly above them at different angles, so that what we see is a series of horizontal stripes diminishing in size as the water recedes from us. The colours of the reflections are always slightly dulled versions of the features being reflected.

Possible colour mixtures: water

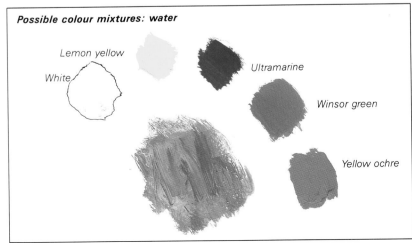

Lemon yellow

White

Ultramarine

Winsor green

Yellow ochre

Possible colour mixtures: water

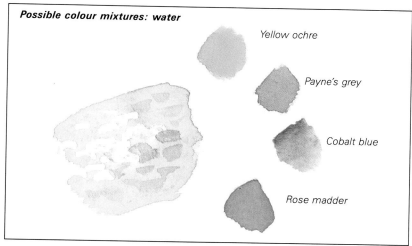

Yellow ochre

Payne's grey

Cobalt blue

Rose madder

San Giorgio Maggiore, Morning Light
by Ken Howard, watercolour, 7×9in/
17.7×22.9cm. This picture gives a
wonderful impression of the wind-
whipped waves in the pinkish-grey
morning light. The artist has used a
special method — of laying down
touches of opaque paint (Chinese white
and Naples yellow) and then laying thin
washes over the top. He finds this
method more satisfactory than using
opaque paint on top of washes, as it
gives a more subtle effect.

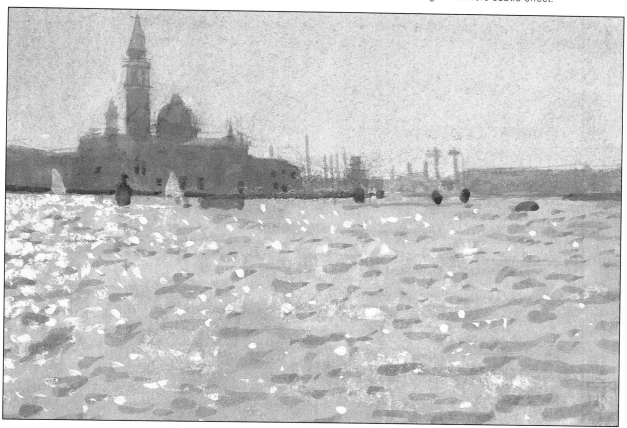

SKIN

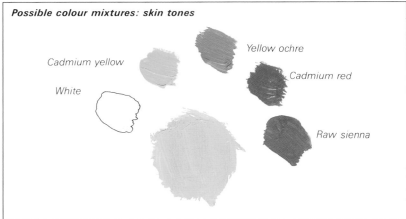

Possible colour mixtures: skin tones

Cadmium yellow

White

Yellow ochre

Cadmium red

Raw sienna

Portrait of Patrick Gould by Robert Buhler, oil, 20×24in/50.8×61cm. *Underpainting in thin ochres and umbers can still be seen in the finished painting. The artist has chosen this warm, golden colour for the underpainting because it echoes the colours in the face, and the small patches which have been allowed to show through the greenish grey of the background create a harmonious whole. The skin itself is given colour with thicker paint in pinks, dull reds and dusty yellows, with grey-blue describing the shadows under the jaw and in the folds of the ear.*

W hat colour is skin? The answer is that no two skins are alike, even within the same ethnic group. A "white" person can be ruddy complexioned or sallow; a "black" person can be pale golden, rich brown or almost blue-black. As skin folds or stretches or goes round corners, its colour changes also. Look at your own hand and see this for yourself. From a variegated pattern of warm and cool pinks on the palm, the colours change to a completely different set on the back, from the loose, folded skin of the knuckles to the tighter skin of the finger tips.

There are various paints on the market called flesh tints, pinkish colours which are supposed to resemble the colour of white (Caucasian) skin. These are best avoided, since they seldom coincide with the colours of real skin, and an additional danger is that all the colours in one painting will tend to be too similar and hence lifeless. With suitable mixing you can quickly match many of the colours of white skin. Addition of a little ultramarine or violet makes cool colours. Additions of reds, ochre, burnt umber or burnt sienna make warmer colours. Instead of starting with, and diverging from, one colour, I find it is always better to try to converge on a range of skin tones by mixing a few widely different paints. There is one

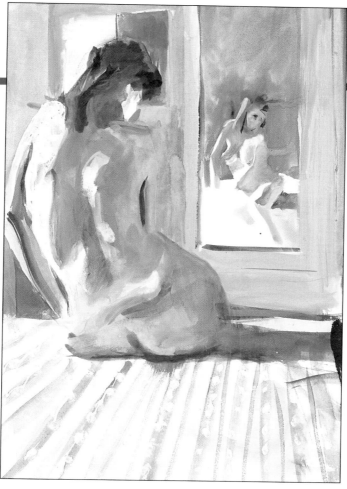

Nude Study by Stan Smith, oil, 12×18in/ 30.5×45.7cm. The figure has been lit from the side, producing very strong tonal contrasts, and the artist has chosen a high tonal key so that the lightest areas of the skin are painted almost pure white and the darkest areas on the right are a cool grey. The colours we think of as "flesh" tones, warm pinkish browns, appear only in the middle tones, and here there is quite a wide range of colour mixtures made from burnt sienna, burnt umber and a little alizarin crimson in varying quantities. The right shoulder and arm merge into the wall behind so that attention is not stolen from the image in the mirror.

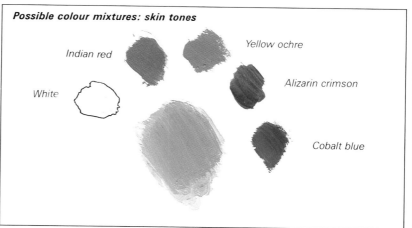

Possible colour mixtures: skin tones

Indian red

Yellow ochre

White

Alizarin crimson

Cobalt blue

version of a proprietary "flesh tint" which I find I can match exactly in oils by mixing roughly equal quantities of white, alizarin crimson and yellow ochre with a tiny bit of cadmium red. By starting with these colours and mixing them in different proportions, a far more interesting range of skin tones can be created. I sometimes mix white, Naples yellow (a very useful colour here) or ochre, burnt sienna and raw sienna, adding touches of cobalt blue,

crimson or violet to obtain the exact colour required.

The colours of each individual's skin depend on many different factors, but degree of pigmentation is the cause of its overall appearance. This depends both on race and on the amount of exposure to the sun. The painter must observe not only the colour relationships between the different areas of one body, but also the relationship of these colours to the surroundings. A lightly sun-

tanned skin will appear a warmer overall colour in relation to the surroundings than will a pale, cooler skin. This will affect the proportions of the warm and cool paints used to mix the colours: cadmium red and yellow ochre are warm colours; cobalt blue, Payne's grey and viridian are cool. A black skin may at first glance appear to be variations on raw umber, indeed it is possible to mix most of the colours you need by adding to this either warm ochres or

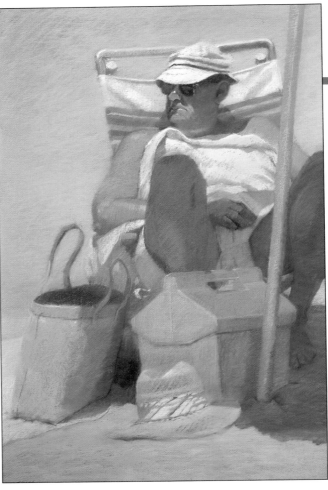

Beach Series Number 5 *by Sally Strand, pastel, 24×36in/61×91.4cm. People at leisure, in informal poses such as this, are the artist's special interest, and she observes and paints the colours of skin and clothing with both daring and accuracy. A wide range of hues has been used for the colour in the man's sunburnt skin, from deep pinks, mauves and reds on the legs and shadowed side of the face, through the more conventional "flesh pink" of the shoulders to the brilliant cherry red of the nose. We can almost feel the heat of the sun.*

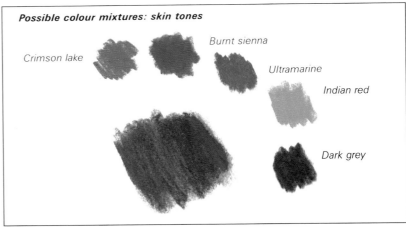

Possible colour mixtures: skin tones

Crimson lake

Burnt sienna

Ultramarine

Indian red

Dark grey

reds or cool blues and greens. Again I prefer to obtain the various — and far more interesting — browns by mixing reds, blues and greens (eg. cadmium red, ultramarine and viridian) with yellow ochre.

It is really pointless to generalize further, because each individual in each situation differs so enormously, but it may be helpful to examine some of the points to watch out for when observing and painting skin. Stretched skin, such as that on the forehead, tends to be pale and cool, while loose or wrinkled skin is usually darker but warmer. Skin is sometimes shiny, particularly on the forehead and nose, where there are often reflected highlights. These tend to be pale and cool, often with a marked blueish tinge, varying according to the light source being reflected, which mix with the "actual" colour of the skin. On a dark skin they contrast sharply; on a pale skin they are less obvious, but are still just as important.

Skin varies in transparency, so its colour is partly determined by the amount of blood showing through. It may be thin and transparent on the face, particularly the nose and lips, or rough and opaque on the back of the hand. Stretching of the skin squeezes underlying blood away so the colour pales — the skin over a clenched fist is an example. Veins underlying the skin will appear blueish, for instance on the temples and

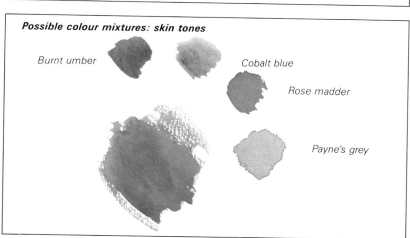
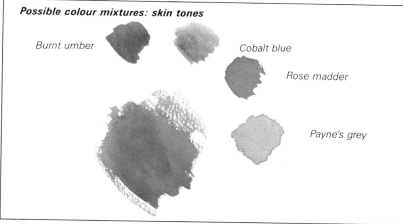

Possible colour mixtures: skin tones

Burnt umber

Cobalt blue

Rose madder

Payne's grey

Dancer by David Hutter, watercolour, 14½×10in/36.8×25.4cm.

Quick Sketches by David Hutter, watercolour, 13½×19in/34.3×48.3cm.

*At first glance, these drawings seem almost monochrome, but look more closely, particularly at the heads in **Quick Sketches,** and you will see a lot of different colours in the "browns." In the darkest areas there are blueish and purplish tints, while the lighter ones are a clear orange-brown. The artist has used a basis of burnt umber, a rich, warm colour, with additions of cobalt blue, rose madder, raw sienna and Davy's grey.*

neck, and a man's face may have a blueish shadow where it has been clean-shaven. In the true shadows, you may see a variety of purples, blue-greys and cool browns, which can be made by mixing white and raw umber with the necessary amounts of violet or ultramarine.

So far I have referred to the mixtures of colours on the palette to equate to each portion of skin being dealt with. There are other techniques which can be used to give the

impression of skin. In acrylics, glazing is an effective method of gradually building up the colours on the painting itself by adding layer upon layer of thin paint washes. As long as the white ground continues to show through, the paint will retain a certain luminosity appropriate to the rendering of skin. The same is true for washes in watercolour, although the fewer used the better, otherwise the paint looks overworked and muddy. You could try

partial mixing — keeping little patches of unmixed colour lying mosaic-like over the surface. An effective way of breaking up colour is to add little dabs of one colour (say a cool, blueish "skin tone") over another, warmer one, or vice versa. Pastels lend themselves to broken colour, since it is difficult to use them in any other way, and are thus excellent for suggesting the vibrant luminosity of skin.

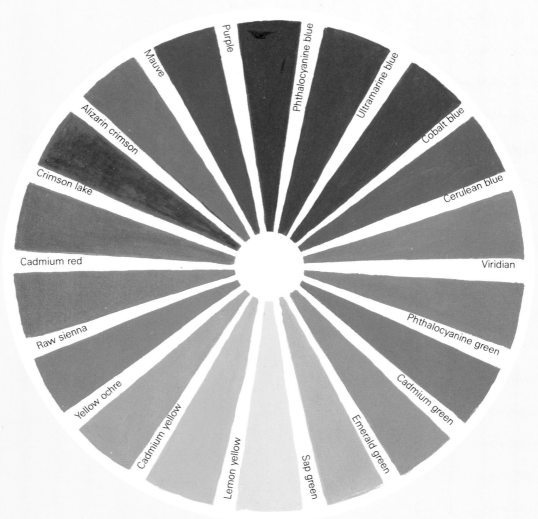

The labels on the colour wheel, reading clockwise from top:

Purple, Phthalocyanine blue, Ultramarine blue, Cobalt blue, Cerulean blue, Viridian, Phthalocyanine green, Cadmium green, Emerald green, Sap green, Lemon yellow, Cadmium yellow, Yellow ochre, Raw sienna, Cadmium red, Crimson lake, Alizarin crimson, Mauve

The colour wheel is a useful device for working out how different combinations of colours can be used together to advantage. Some colour wheels show the pure colours based on those of the spectrum (the colours of light) but this one is a pigment wheel, which includes all the "basic palette" colours. Notice that the warm·colours, the reds and yellows, are close together, with the cool blues and greens on the other side. The colours directly opposite one another (red and green, yellow and violet) are the complementary colours. Both complementaries and warm and cool colours can be used to create moods and effects in a painting, and on the following pages we'll be looking at how this is done.

6

DOES THE PICTURE WORK?

So far we've looked at the more practical side of painting — how to mix colours, how to match them to a subject, and how to use them to create convincing and lifelike effects. All this is very important, indeed it's the alphabet of painting, but there are other considerations too. Having learnt the alphabet, we now have to learn how to make words — or in this case paintings. A painting is not just a copy of life; it exists in its own right, and to be really successful it needs a certain amount of thought and planning. In this chapter we're going to look at how to make the painting "work", and how to use colours and their various properties to make an individual and personal statement.

As we saw in Chapter 2, the three colours which cannot be mixed from any others are the three primaries: red, blue and yellow. When any two primary colours are mixed together they form a secondary colour: a mixture of red and blue gives purple; red and yellow form orange; and blue and yellow form green. If all the primaries are mixed in varying proportions, or if a primary colour is mixed with a secondary one, the result is called a tertiary colour. These consist of a virtually endless range of greys and browns.

The three primary colours can be placed one at each corner of a triangle with mixtures of each pair along each side representing the secondaries. In the centre of the triangle are the tertiaries, the neutral colours mixed from the others. Such a triangle is a good way of showing the various mixtures that can be obtained. It can be rounded off to form a colour wheel, which most people have come across in books about painting, but the advantage of the triangle is that it shows the original colours clearly at the corners, whereas in a colour wheel you have to search for them among all the others.

COMPLEMENTARY COLOURS

If you stare at a bright red area of colour for a minute or two and then transfer your gaze to a white sheet of paper you will see a green after-image. The particular green that you see is referred to as the complementary of the particular red you looked at. If you reverse the process and start with an area of green, you will have a red after-image. Every colour has its complementary, which can be found in the same way. These have nothing to do with the nature of light itself, but arise for physiological reasons related to the way our eyes perceive light. You will notice that on the colour triangle each primary colour has its complementary on the opposite side: blue is opposite orange, red opposite green and yellow opposite purple. When you mix two complementaries you get a neutral tertiary colour because you are in effect mixing the three primaries. In terms of painting, unmixed complementary colours are useful because they intensify one another. A small patch of red in a large area of green can make the green look that much brighter. Nearly all painters have used this kind of juxtaposition to some extent: seascape painters sometimes "invent" an orange sail to enhance a blue sea, and Van Gogh sometimes used complementaries to create a deliberately jarring effect. In one of his paintings, he said that he had "tried to describe the terrible passions of humanity by means of green

Beach at San Bartolomeo by Andrew Macara, oil, 40×50/101.6×127cm. Our eyes often perceive the shadows in a scene as being the complementary colour to that of the illuminated part, and here the artist has played this up, giving a violet tinge to the shadowed area of the yellow beach. For the path on the right, he has used a purer violet which perfectly balances its complementary yellow at the left of the picture.

124

and red."

Using complementary colours

Instead of using tone to describe form, modelling can be achieved by the use of complementary colours. The warmer members of each pair of complementaries are used to paint the highlights, while their cooler partners are used for the shadows, for example an arm may be painted in yellow, with the shaded portion in violet.

Complementaries placed side by side form a particularly bright and eye-catching boundary which can be used to draw the viewer's attention to that part of the picture. This effect occurs even when the colours are quite muted; look, for instance, at

the pale yellows and violets in Andrew Macara's painting of a beach. Jo Skinner in her *Chrysanthemums* (see page 99) has made good use of yellow and violet to enhance the colours of the flowers, and Robin Mackertitch has used reds and greens in a similar way in her *Three Geraniums*. The cooler member of a pair of complementaries tends to recede while the warmer one advances.

Three Geraniums by Robin Mackertitch, oil, 24×20in/61×50.8cm. Green and red are complementary colours, and the boundaries where the two meet can sometimes be striking, even quite dazzling if they are used in pure form. Here the greens and reds are relatively quiet, but you can see how the leaves at the lower left which are surrounded by red provide a more forceful image than those surrounded by blue further up the picture. The area on the lower right could have been dead and meaningless had it not been for the triangle of green in the corner. This, contrasting with the red cloth, acts as a stabilizer by balancing all the activity in the plants themselves.

TONE

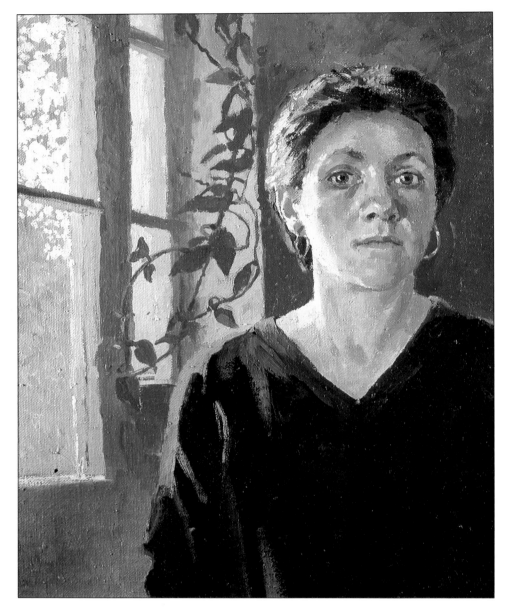

This simply means the lightness or darkness of a colour, and has nothing to do with the "blueness" or "redness" of the paint. Tone is just as important as colour in a painting, and many painters, particularly in the past, have been more interested in tone than in colour. Paintings were traditionally built up in monochrome, with the colours put in last on top of a detailed tonal underpainting. It is an interesting fact that a black and white photo of a painting in which the colours were painted quite differently from the colours of the subject but the tones kept true to life would look entirely "normal."

The colours of the spectrum have varying tones because our eyes are more sensitive to some colours than others. Yellow is always light in tone because our eyes are most sensitive to it, while pure red and pure blue appear the darkest. Incidentally, in dim light our eyes are most sensitive to green and blue, the reds becoming very dark.

Self-portrait by Window by Lucy Willis, oil, 15×12in/38×30.5cm. Large dark areas contrast strongly with equally large light ones in bold geometric shapes — the rectangles of the window, the triangle of the neck, the circle of the face and the crescent of the hair. The delicate, sinuous forms of the plant relieve the starkness of the picture, and also help to relate the pattern on the facial features to the window, and hence to the rest of the painting.

Tonal key

As well as a colour key a painting has a tonal key, which can be described as high (light colours) or low (dark colours). It can also encompass a wide scale of tones from very dark to very light. The tonal key can be used to set the mood of a painting. A dark picture tends to be sombre or serious, whereas a picture in a high key may be more light-hearted. This is by no means a hard and fast rule. One may expect a night-time painting to be dark, but this is not necessarily the case. Very often a successful painting depicting a night scene may be in a high key. Conversely a picture of a subject in broad daylight or even in bright sunlight may be painted in dark tones. As in the case with colour, too many tones in one painting may cause confusion to the viewer, possibly making the picture appear disjointed and destroying its overall harmony.

Melanie Contre Jour by Ken Howard, oil, 9×7in/22.9×17.8cm. This painting depends for its effect almost entirely on the pattern made by the distribution of lights and darks — colour is minimal, verging on monochrome. Imagine how dull the picture would be if the chair were not there. Its pale seat contrasts with the shadow to the right, while the dark area beneath it is in counterpoint to the pale-coloured floor. The bars of the chair connect the upper and lower halves of the picture, and are echoed by the horizontals and verticals of the window frame. Turn the picture upside down so that you see it as an abstract arrangement.

WARM AND COOL, DARK AND LIGHT

A picture can be said to be painted in a particular colour key rather in the way that a piece of music is written in a key which the composer thinks is most fitting for the mood and character of the piece.

One can often describe a painting as having an overall main colour. For example it may be predominantly a pale or dark green, or a dominant overall red colour — or indeed any colour you can think of. Sometimes a painting may be in a simple colour combination of more than one main colour.

This overall colour effect is called the colour key of a painting. You could assign a colour key to most of the paintings illustrated in this book.

If a painting does not have a definite colour key it may well be unsuccessful. Imagine a piece of music written in a random motley of keys. The result would be a disaster unless in very skilled hands. Just one or two dominant colours give distinction to a painting. If there are too many they compete, drowning each other out instead of adding together. Likewise a key or theme is needed in other art forms including such everyday ones as cooking or choosing what to wear.

Colour temperatures

Some colours are described as "warm" and others as "cool," the former being the reds, oranges and yellows and the latter being the

Portsmouth by Albert Goodwin, oil and pastel, 8×12in/20.3×30.4cm. This picture is painted in a colour key of pale blue, with all the blues, blue-greys and violets closely related to one another. Greens and reds have no place here, and the only other clearly defined colour is orange which, being the complementary of blue, heightens the apparent intensity of sky and water.

Whitley Bay Looking South by Jacqueline Rizvi, watercolour and bodycolour, $8\frac{1}{2} \times 11\frac{3}{4}$in/21.6×29.8cm. The two paintings on these pages show the use of high and low "keys" in painting. This is a very high-key picture, eloquently capturing the luminous light of sky and sea. Imagine a dark or bright colour placed in the foreground — it would have completely destroyed the effect. The lightest touches are pure opaque white laid over the basic watercolour washes, and the darkest, the figures and other features on the beach, are nowhere near the darkest end of the tonal scale. The colour range is also very subtle, with the muted blue at the top of the sky appearing quite brilliant in the context of the pale, warm greys with their hints of yellow and pink.

Strand on the Green by William Bowyer, oil, 40×50in/101.6×127cm. This is largely a low-key painting, with most of the colours dark, almost black in places. The painting nevertheless has great brilliance and power, due not only to the colours themselves, but also to the method of paint application and the contrast of tones. Look, for instance at the luminous blues, pinks and violets in the middle ground, and the way the colour is broken up and heightened by the small dark areas of scumbled paint. The brightest part of the painting is the river, contrasting sharply with the dark shapes of the boats and the deep, rich blues beyond.

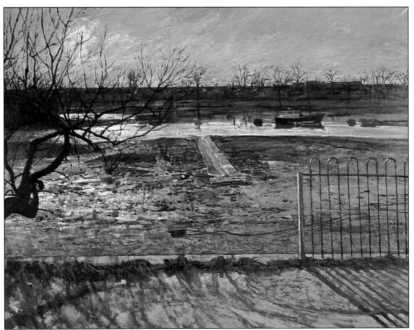

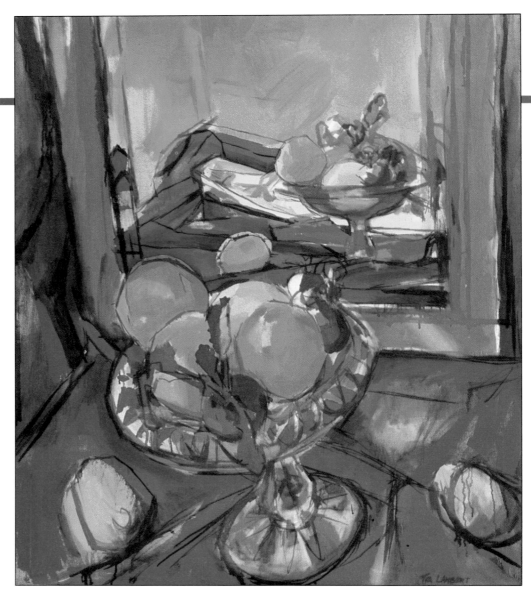

blues, blue-greys and blue-greens. A painting with an overall blue colour may give you a feeling of tranquillity, while one in reds, oranges and yellows may give an impression of warmth. The origin of these temperatures may be partly a matter of everyday associations — an overheated person goes red in the face; the hot sun is orange-red; blocks of ice have hints of blue, as do the shadows in a snow-covered landscape. But whatever its origins, colour temperature is a useful tool in painting, particularly to create a feeling of space and recession. Just as a line of distant hills appears as a cool blue-grey, the cool colours tend to recede, while the warm ones push themselves into the foreground. How-

ever, like everything to do with colour, this is relative. Although the blues are theoretically all cool, some are warmer than others and some reds cooler. For instance, Prussian blue is cooler than ultramarine, which has a hint of red in it, while alizarin crimson is cooler than cadmium red.

A successful painting usually has contrasting or interlocking areas of either warm and cool colours or of dark and light tones, or often both. A painting which lacks these contrasts, for example, one that is all pale *and* painted entirely in cool blues and greys, besides failing to catch the eye, will be off balance and unpleasant to look at. It is a good idea to try to counteract warm areas

Glass Comport by Tia Lambert, acrylic, 40×34in/101.6×86.4cm. The interplay of bright, warm reds and yellows with equally bright but cooler blues and greens creates a lively and vigorous, but far from restful, image. It is interesting to see how the warm colours advance and the cooler ones recede, even though the position of the objects in space tells us something different. For example the red mirror frame jumps towards us although it is actually behind the blue cloth in the foreground, while the yellow patch in the reflection, the furthest away from us, is one of the most dominant features in the composition.

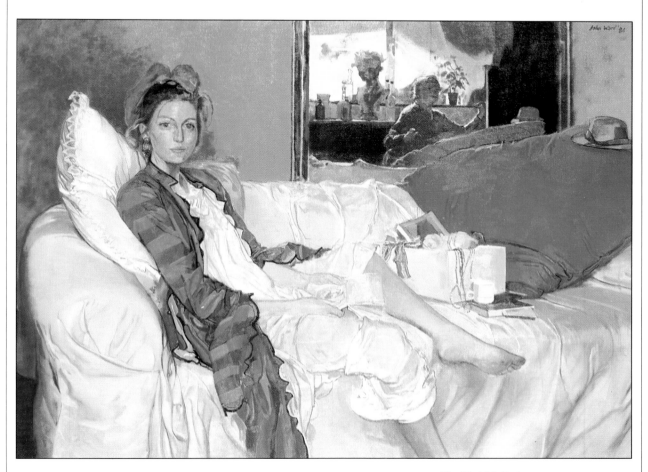

with cool and vice versa even if it's just by using a warm ground showing through paint which is otherwise mainly cool. I personally paint all my water scenes on warm grounds.

As we have seen, cool colours tend to recede, but in spite of this, the shape of areas is usually more powerful than the colour temperature. The nearest feature in Hans Schwartz's *Market, Collioure* (see page 138) is a cool blue at the bottom right-hand corner. However, in the distance (at the extreme right) is a woman in a warm orange dress which tries its best to jump out at you but is continually pushed back into the distance again simply because we know that is where it

belongs. Another interesting play between warm and cool is found in Tia Lambert's *Glass Comport* (opposite). Look also at the olive trees on a red background in Frederick Gore's painting *Val D'Entre Conque*, on page 68.

Colour balance
The distribution of light and dark areas, warm and cool areas and the pattern made up by its colours gives rise to the balance of a painting. A badly balanced painting is one that does not make a whole; that is, one which looks as if it needs a portion chopped off, or one that gives the impression that it is really part of a larger picture.

The Turkish Robe by John Ward, oil, 36×40in/91.4×101.6cm. This picture, unlike Tia Lambert's, uses predominantly cool colours in a very carefully controlled range, and gives an impression of peace and relaxation. But even here some colours are relatively warm. For instance the striped gown is made up of alternating bands of cool blue and warm ochre, continued into the hair, while the pinks, yellows and oranges of the open gift box are considerably warmer than the blue of the cushion behind. The sheet and nightdress, as well as the face, hands and feet, are a mixture of cool and warm colours, reflecting the dominating blues.

PATTERN AND COLOUR ECHOES

A painting needs to have a uniform pattern, whether simple or complex. The simplest type is the even distribution of forms over the entire picture surface. The danger here is that the picture can turn out dull and lacking life, but if the shapes direct your eye around the picture's surface this need not be so. A landscape consisting of a patchwork of fields gives a uniform scattering of shapes, as can be seen in *Mistral Plain*. What keeps the eye moving is that certain shapes and their colours are echoed through the picture, drawing the viewer's attention from the foreground to the distance and back again. The main shapes in the middle ground of this painting are the rectangular, pale yellow corn-fields which repeat themselves into the distance, and are echoed in the shapes of the white buildings.

Sometimes when you have nearly finished painting you may find that a large area is bare and seems to have little relation to the rest of the picture. Ideally you should have foreseen this situation and taken steps to prevent it, but you can often save the picture at the last minute by echoing one or two features of the interesting part of the picture in the empty part. Imagine Diana Armfield's pastel (opposite) with the table top totally bare in the lower half of the picture. It would be top-heavy and rather absurd. The man's face to the left is a striking, roughly circular patch of pinkish ochre. The peach in the fruit bowl echoes his face, since its shape and approximate colour are similar. The table top now bears a relation to the top half of the picture. Not only this, the patches of dark blue of the bunches of grapes in the bowl echo the dark heads of two more people at the top of the picture. Continuing to explore the table top, we see that the red wine in the glass at the extreme bottom left again echoes both the peach and the man's face, thus linking the lower left quarter of the picture surface with the rest. The man's face, the peach and the wine glass are the corners of a triangle. The dark bunches of grapes and the two dark heads are corners of a rectangle. These interlocking shapes help to hold the picture together.

Mistral Plain by Robert Buhler, oil, 40×30in/101.6×76.2cm. This painting has a very strong pattern element. The first thing we notice is the chequerboard effect of the regular, rectangular fields, which become increasingly linear towards the mountains, creating an obvious perspective. The shapes of the fields are echoed in the white buildings, while the trees that surround them have their echoes in the ears of wheat. Colours are repeated too. Notice how the red of the poppies appears again in the roofs, though in more muted form, so that they keep to their place in the middle distance.

Supper with Bernard off the Piazza Bra by Diana Armfield, pastel, 8×6¾in/ 20.3×17.1cm. This picture comprises three main layers, the top one being the blue background, the middle one the white shirts, tablecloths and chairs, and the lower one the foreground with its still-life group of fruit, bottle and glasses. But the viewer is encouraged to look from one part of the picture to another by the repetition of small coloured shapes — the man's face, the peach and the remains of the wine in the glass, the dark fruits and two dark heads above it, the green bottle and the similar-coloured pillars above — so that the layered structure only becomes apparent if you look at the picture upside down.

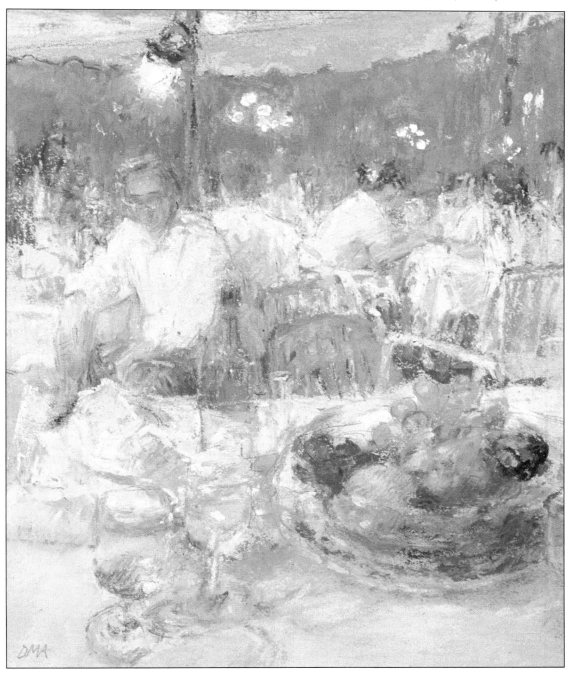

Beach Study by Arthur Maderson, oil,
8×10in/20.3×25.4cm. This little painting
is held together by the way similar
patches of colour have been repeated
throughout, even though they are
describing very different subjects. For
example, there are near-identical blue
patches representing the boy's hair, parts
of his shirt, pebbles on the beach and
buildings in the background; the pinks of
the skin appear again in the buildings,
and the mauve in the sky has also been
used for shadows on the figures and
foreground pebbles.

Bank Holiday, Hyde Park by Robert Buhler, oil, 24×20in/61×50.8cm. There is a fairly even scattering of shapes and colours throughout the picture, but the artist has used some special devices to keep the eye moving around the scene. The pale grey colour of the coat at the bottom centre is repeated in the grey sky vertically above it at the top, and distant tree trunks echo the figures. Finally, the few larger cream and white patches take the eye in among the crowd, to rest in the centre where the brightest reds contrast with the dark green.

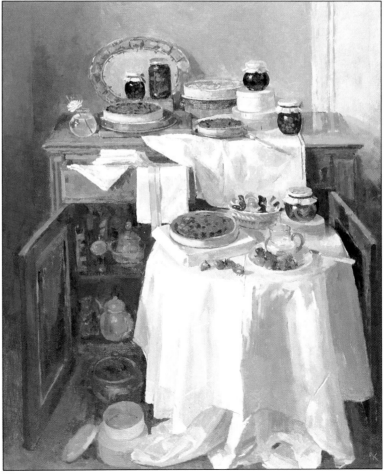

The Still Life Cupboard with Summer Jams and Preserves by Pamela Kay, oil, 30×23¾in/76.2×60.3cm. Drapery is often used by still-life painters to unify a group of diverse objects, and here the tablecloth cascades down the picture like a waterfall, causing the eye to move up and down the picture. Both colours and shapes are repeated and echoed throughout the composition in obvious and less-obvious ways — notice how the mauvish grey of background and foreground occur again in the pots seen through the open door of the cupboard,

HARMONY

Here again there are analogies with music, also food and dress. Some combinations of musical instruments sound better than others; the colours and patterns of items of clothing may go well together or they may not; food receives its overall taste through a combination of flavours — some nicer than others. The order in which you eat your food is important also. In the same way the colours of a painting may or may not work together, or harmonize. To some extent the success of a combination of clothes depends on the current fashion, but there will always be certain mixtures that are disastrous and certain colours that clash. These colours are those saturated ones

that are similar enough to compete with each other in a given situation, such as red and orange or two different reds. Shapes can compete with one another in a similar way. Suppose you are sitting in a train opposite a thin-faced person and a very round-faced one. If you gaze at the long thin face for a bit, the round face begins to look quite ridiculous, and the same happens when you have got used to the round face.

A painting which may be thought to suffer from the problem of colour competition is my own *Still Life with Daffodil* (see page 56). The blues on the mug, the striped bowl and the little flower pattern at bottom left tend to compete, as do the daffodil, the orange and the apple. To my own

Rolled Hay by Doug Dawson, pastel, 17×19in/43.2×48.3cm. Landscape subjects such as this to some extent create their own harmony, which the artist can accentuate by controlling the colours. The best way to do this is to use closely related colours, and to repeat them throughout the painting. Here the colour key is based on pink and green, and although these are near-complementaries, they harmonize perfectly because they are precisely equal in intensity. The artist has taken the pale yellow greens of the distant fields into the sky instead of attempting a faithful description of "sky colour".

Still City, Early Dawn by Robert Buhler, oil, 40×30in/101.6×76.2cm. A subject like this must have no jarring note, or the impression of peace and silence would be destroyed. The sky, water and buildings are all closely related in colour, since they all contain differing proportions of the same blue. The range of tones is quite small too: the whites of the moon and church are not pure but contain blues and yellows, while the shadowed sides of the buildings are a relatively pale blue-grey mixture.

mind, the picture lacks colour harmony, but others might not agree.

If you use a limited palette, you will be using the same colours over and over again, and a certain harmony will naturally arise. This is especially true if you don't mix the colours too much so that they are continually repeated throughout the picture. This is one of the reasons why I have recommended earlier in this book a very limited palette for watercolours, but it can be a good discipline to work in this way for oils too.

A natural landscape has its own self-imposed harmony, indeed we probably receive our ideas about colour harmony in the first place from our surroundings. If you are painting a landscape, adhering faithfully to the colours before you, the painting is likely to inherit a natural harmony automatically.

You will find that you will be repeatedly using certain paints to mix up the colours. On a certain day, for instance, you will find that every colour needs quite a lot of violet or ultramarine mixed in with it, which will set the underlying colour key and establish harmony. A cool picture like this is perhaps best painted on a warm ground so that the coolness has something to relate to. The opposite is true where an overall warmth pervades the picture, such as a desert scene or Mediterranean landscape. This may be most effective if painted on a cooler ground such as raw umber.

Man-made structures, however, frequently do not harmonize with natural landscapes, and may not do so in a painting. For instance a boat, particularly an old one, usually looks well in the sea, but many people would agree that a shiny car does not blend in happily with a forest, lake or mountain scene. A car painted in, say, emerald green would be shown up as being false and artificial against a background of natural green vegetation. Similarly the same colour combination in a painting may produce the same reaction from the viewer. But this is by no means always the case: sometimes an unexpected touch of colour which would normally clash with its neighbours is vital in a picture.

Market Collioure *by Hans Schwartz, oil, 22×30in/55.9×76.2cm. Here the artist has deliberately avoided harmony because he wanted to create the impression of a busy, bustling scene. The bright colours jump out at you, keeping the eye constantly moving over the picture surface. The effect is accentuated by the way the paint has been applied — rather thin, with bold directional brushstrokes. But the "disharmony" is carefully controlled, and the picture is held together by the way the dominant blues and greens have been repeated all over the surface.*

Diane's Pink Gown by Doug Dawson, pastel, 15×18½in/38.1×47cm. The most obvious way to create harmony in a painting is to use cool or pale colours, but here all the colours are bright and hot — almost clashing. But the picture works beautifully, firstly because all the reds, pinks and browns are closely related, and secondly because the tones have been very carefully controlled. Notice the bright pink highlights on the shadowed left arm and shoulder, which separate the deep pink from the red-brown of the door. The blue of the curtain and the paler blue of the sky seen through the window have been "tied" to the rest of the picture by areas of pink repeated from the dress.

PAINT IDENTIFICATION CHART

	WINSOR & NEWTON	OIL	WATERCOLOUR	ACRYLIC	ROWNEY	OIL	WATERCOLOUR	ACRYLIC	GRUMBACHER	OIL	WATERCOLOUR	ACRYLIC
WHITES	Titanium white	•		•	Titanium white	•		•	Superba (titanium)	•		•
	Chinese white			•	Chinese white		•		Chinese white		•	
BLUES	French ultramarine	•	•		French ultramarine	•	•	•	French ultramarine	•	•	
	Ultramarine			•	French ultramarine	•	•	•	Ultramarine blue	•		•
	Cobalt blue	•	•	•	Cobalt blue	•	•	•	Cobalt blue	•	•	•
	Cerulean blue	•	•	•	Coeruleum	•	•	•	Cerulean blue	•	•	•
	Prussian blue	•	•		Prussian blue	•	•		Prussian blue	•	•	
	Phthalo blue			•	Monestial blue	•	•	•	Thalo blue	•	•	•
	Winsor blue	•	•		Monestial blue	•	•	•	Thalo blue	•	•	•
REDS	Alizarin crimson	•	•		Crimson alizarin	•	•		Alizarin crimson	•	•	•
	Cadmium red	•	•		Cadmium red	•	•	•	Cadmium red	•	•	•
	Permanent rose	•	•		Rowney rose	•			Thalo red rose	•		
	Carmine	•	•		Carmine (alizarin)	•	•		Thalo crimson		•	•
	Vermilion	•	•		Cadmium scarlet	•		•	Vermilion (hue)		•	•
	Crimson lake	•	•		Crimson alizarin	•	•		Alizarin crimson	•	•	•
	Naphthol crimson			•	Vermilion (hue)			•	Grumbacher red			•
	Venetian red	•	•		Venetian red	•	•	•	Venetian red	•	•	
	Light red	•	•		Light red	•	•		English red light	•	•	
	Burnt sienna	•	•	•	Burnt sienna	•	•	•	Burnt sienna	•	•	•
YELLOWS	Lemon yellow	•	•		Lemon yellow	•			Zinc yellow	•		
	Cadmium yellow	•	•		Cadmium yellow	•	•	•	Cadmium yellow	•	•	•
	Naples yellow	•	•		Naples yellow	•			Naples yellow	•	•	
	Yellow ochre	•	•	•	Yellow ochre	•	•	•	Yellow ochre light	•	•	•
	Raw sienna	•	•	•	Raw sienna	•	•	•	Raw sienna	•	•	•
GREENS	Viridian	•	•		Viridian	•	•		Viridian	•	•	
	Winsor emerald	•	•		Rowney emerald	•			Permanent bright green	•		
	Winsor green	•	•		Monestial green	•	•	•	Thalo green	•	•	•
	Phthalo green			•	Monestial green			•	Thalo green	•	•	•
	Cadmium green	•			Cadmium green	•			Permanent green light	•		•
	Chrome green	•			Chrome green	•			Permanent green dark	•		
	Hooker's green		•	•	Hooker's green		•	•	Hooker's green		•	•
	Permanent green light			•	Bright green			•	Thalo yellow green		•	•
	Terre verte	•	•		Terre verte (hue)	•	•		Green earth	•	•	
VIOLETS	Winsor violet	•	•		Permanent mauve	•	•		Thio violet	•	•	•
	Magenta	•			Permanent magenta	•	•		Thio violet	•	•	•
	Dioxazine purple			•	Permanent violet			•	Grumbacher purple			•
BROWNS	Raw umber	•	•	•	Raw umber	•	•	•	Raw umber	•	•	•
	Burnt umber	•	•	•	Burnt umber	•	•	•	Burnt umber	•	•	•
BLACKS & GREYS	Lamp black	•	•	•	Lamp black	•	•		Lamp black	•	•	
	Ivory black	•	•	•	Ivory black	•	•	•	Ivory black	•	•	
	Mars black	•		•	Mars black	•		•	Mars black	•		•
	Payne's grey	•	•	•	Payne's grey	•	•	•	Payne's grey			•

HOW TO USE THIS CHART

Owing to the constraints of space, this chart deals only with artists' quality ranges of oils, watercolour and acrylics.

The colours listed are those referred to in this book and their approximate equivalents.

Similar composition or similar colour value determines equivalent colour but don't expect an exact match from range to range.

In each of the ranges names of colours will vary. In addition to terms such as "light," "dark" and "deep," accompanying a colour name, there may also be rearrangements of words. Allow for this when you use the chart.

HOLBEIN	OIL	WATERCOLOUR	ACRYLIC	LEFRANC & BOURGEOIS	OIL	WATERCOLOUR	ACRYLIC	SCHMINCKE	OIL	WATERCOLOUR	ACRYLIC
Titanium white	●		●	Blanc de titane	●		●	Titanweiß	●		●
Chinese white		●		Blance de chine		●		Perm. chin. weiß		●	
Ultramarine light	●	●	●	Outremer No2 clair	●	●		Ultramarin hell	●	●	●
Ultramarine deep	●	●		Outremer No1 foncé	●	●	●	Ultramarin dunkel	●		
Cobalt blue	●	●	●	Bleu de cobalt	●	●	●	Kobaltblau	●	●	●
Cerulean blue	●	●	●	Bleu céruleum	●	●		Cöwnblau	●	●	
Prussian blue	●	●	●	Bleu de prusse	●	●	●	Preußischblau	●	●	
Transparent blue	●			Bleu hortensia	●	●		Phthaloblau	●	●	
Indigo		●		Bleu hoggar	●	●	●	Phthaloblau	●	●	●
Crimson lake	●	●		Laque garance cromoisie	●			Alizarin krapplack	●	●	
Cadmium red	●	●	●	Rouge de cadmium	●	●	●	Kadmiumrot	●	●	●
Alps red	●		●	Rouge grenat	●			Rublinlack dundeu	●		
Carmine	●	●		Carmin d'alizarine	●	●		Karmin	●	●	
Vermilion	●	●		Vermilion français	●			Zinnoberton	●		
Crimson lake	●	●		Laque garance cramoisie	●	●		Alizarin krapplack	●	●	
Flame red			●	Rouge breughel	●	●	●	Zinno berrot		●	●
Venetian red	●			Ocre rouge	●	●	●	Engwshrot hell	●	●	●
Light red	●	●		Rouge anglais	●			Engwshrot hell	●	●	●
Burnt sienna	●	●	●	Terre de sienna brûlée	●	●	●	Siena gebrannt	●	●	●
Lemon yellow pale	●			Jaune de strontiane	●			Zincgelb	●		
Cadmium yellow	●	●	●	Jaune de cadmium	●	●		Kadmiumgelb	●	●	●
Naples yellow	●	●		Ton jaune de naples	●	●	●	Neapelgelb dunkel	●	●	
Yellow ochre	●	●	●	Ocre jaune	●	●	●	Lichter ocker natur	●	●	●
Raw sienna	●	●	●	Terre de sienna naturelle	●	●	●	Siena natur	●	●	●
Viridian	●	●		Vert émeraude	●	●	●	Chromoxidgrun feurig	●	●	
Emerald green nova	●	●		Ton vert véronèse	●	●	●	Vert paun veronese	●		
Transparent green	●			Vert armor	●	●	●	Phthalogrün	●	●	●
Permanent green deep	●	●		Vert aubusson	●	●		Phthalogrün	●	●	●
Cadmium green	●	●	●	Vert de cadmium	●			Kadmiumgrün	●		●
Compose green	●	●	●	Vert anglais	●			Chromgrün			●
Hooker's green		●	●	Vert de hooker	●			Hookersgrün		●	
Permanent green light	●	●		Vert lumière			●	Permanentgrün hell	●	●	●
Terre verte	●	●		Terre verte	●	●		Böhmische grüne erde	●	●	●
Transparent violet	●			Violet d'egypte	●	●	●	Echtviolett	●	●	●
Rose violet	●		●	Violet de bayeux	●	●	●	Echt-rotviolett	●		
Permanent violet			●	Violet d'egypte	●	●	●	Echtviolett	●	●	●
Raw umber	●	●	●	Terre d'ombre naturelle	●	●	●	Umbra natur	●	●	●
Burnt umber	●	●	●	Terre d'ombre brûlée	●	●	●	Umbra gebrannt	●	●	●
Lamp black	●	●	●	Noir froid	●			Lampenschwarz	●		
Ivory black	●	●		Noir d'ivoire	●	●		Elfenbeinschwarz	●	●	
Mars black			●	Noir de mars	●		●	Schwarz			●
Payne's grey	●	●		Gris de payne		●		Paynesgrau	●	●	

INDEX

Note: page numbers in *italics* refer to pages on which illustrations and captions appear.

CREDITS

The publishers would like to extend their thanks to all those who have helped in the preparation of this book, especially Winsor & Newton for the loan of artists' materials, J. P. Stephenson for the compilation of the chart on pages 140-1, and Tom Robb for help and advice with the many examples of colour mixtures.

Where colour mixtures are suggested in chapters two and five, trouble has been taken to correctly analyse the colours the artists used. However, the suggested palettes are approximations only. In addition, throughout this book the colours have been reproduced within the limitations of four-colour printing.